The FIRST AMERICANS

PHOTOGRAPHS FROM THE LIBRARY OF CONGRESS

Designed by Megan Rickards Youngquist
Edited by Owen Andrews
Photographic Editor Laurence L. Levin
Text copyright © 1991 by William H. Goetzmann.
All rights reserved.
Photography copyright © as attributed with the photographs.
All rights reserved.
Copyright © 1991 by Starwood Publishing, Inc.
All rights reserved.
No part of the contents of this book may be reproduced
without the written permission of the publisher.
ISBN 0-912347-96-1
Color separations by Pioneer Graphic Scanning through
Jinno International.
Printed and bound in Singapore by Eurasia Press
(Offset) Pte. Ltd.

Library of Congress Cataloguing-in-Publication Data

Library of Congress.
 The first Americans: photographs from the Library of Congress /
text by William H. Goetzmann.
 p. cm. — Library of Congress classics)
Includes bibliographical references and index.
IBSN 0-912347-96-1
— — Copy 3 Z663.39.F57 1991
 1. Indians of North America—Portraits. 2. Library of Congress.
Prints and Photographs Division.—Photograph collections.
I. Goetzmann, William H. II. Title. III. Series.
E89.L53 1991
973.0497—dc20 91-12662
 CIP

(Pages 4-5) C.S. BRADFORD, *HIAWATHA AND
MINNEHAHA*, © 1902.

*In this scene from a Philadelphia theater production,
the canoes float in a rubber-lined pool. The play,
based on Henry Wadsworth Longfellow's poem,
typified Victorian sentimentalizing of Native
Americans.*

The FIRST AMERICANS

PHOTOGRAPHS FROM

THE LIBRARY OF CONGRESS

TEXT BY

WILLIAM H. GOETZMANN

STARWOOD PUBLISHING, INC.

WASHINGTON, D.C.

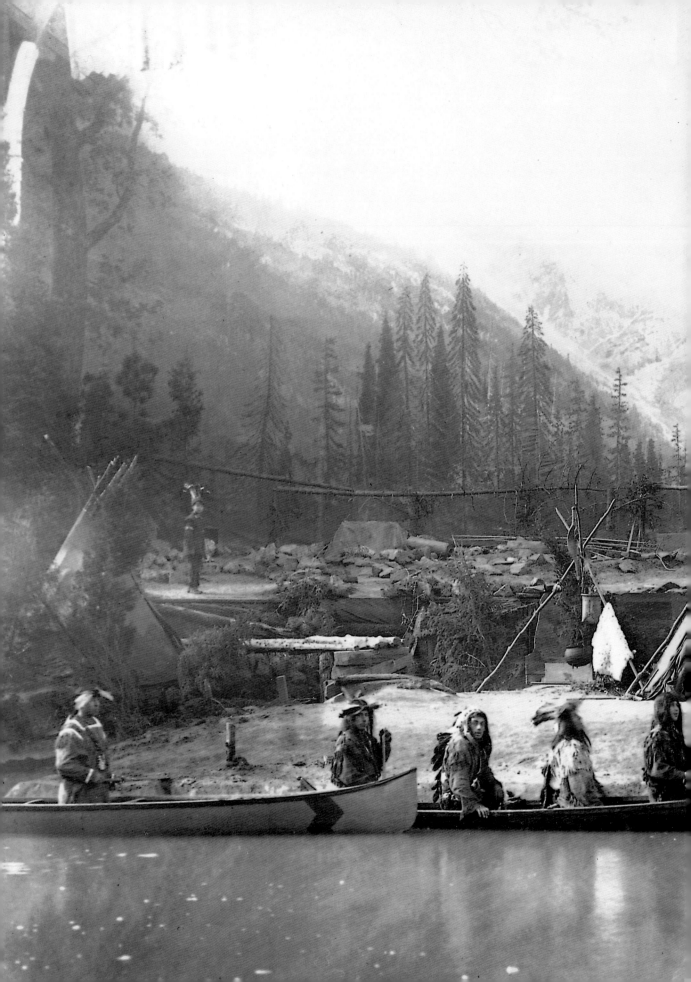

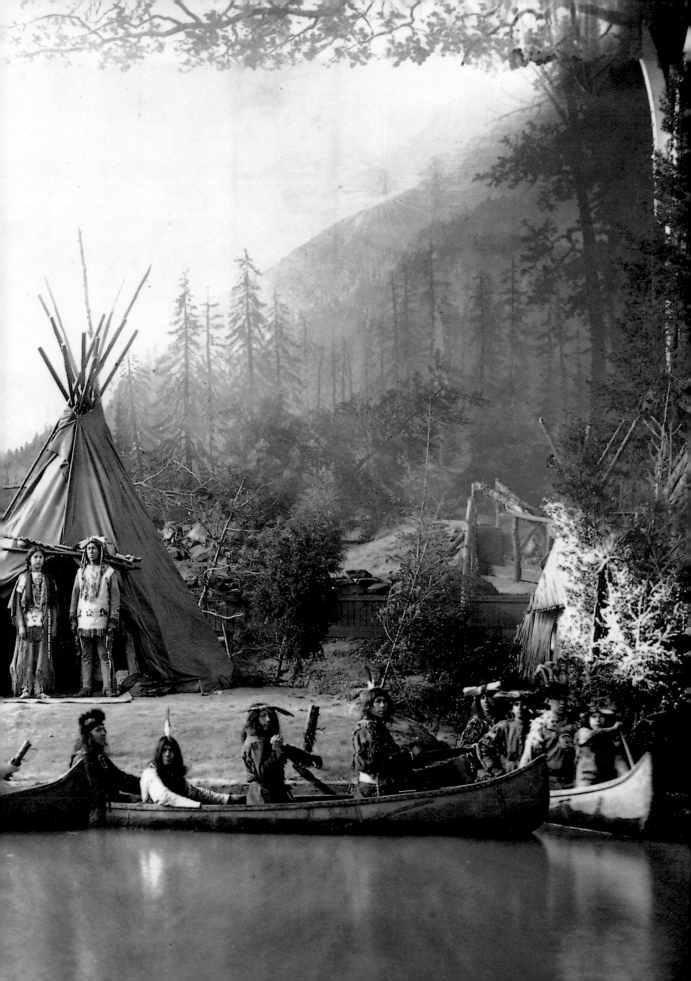

THEY CALLED THEM INDIANS

Native American Photographs at the Library of Congress

T wo purposes inform this book. First, using the resources of the Library of Congress, we are offering a unique photographic record of the fascination with the "Indian"[1] that spread over the United States in the late nineteenth and early twentieth centuries. And second, with these images as text, we hope to cause people to think in fresh terms about photographs and the reality they embody.[2]

The photographs we present are drawn from the work of turn-of-the-century commercial photographers who submitted copies of their images to the Library of Congress for federal copyrights. Out of the thousands of Native American photographs in the Prints and Photographs Division of our nation's library, we have concentrated on images made for sale to a public suddenly curious about the original inhabitants of their country. They were curious for a variety of reasons—because these were picturesque views of exotic peoples, because they seemed to supply information about these peoples, because they embodied sentimental notions about the "vanishing American," and because, no matter how

[1] The reader should note that I have used the term "Indian" to refer to the white man's *vision* of our native peoples. When referring to the actual people themselves, I have used terms such as "natives," "Native Americans," and sometimes just "Americans."

[2] The reader should also note that the raison d'etre for the Library of Congress collection is the certification of copyright for commercial photographs that the photographers hoped to sell, not photographs subsidized as a result of government expeditions or Bureau of American Ethnology studies. The insights afforded into American mass values outweigh these limitations.

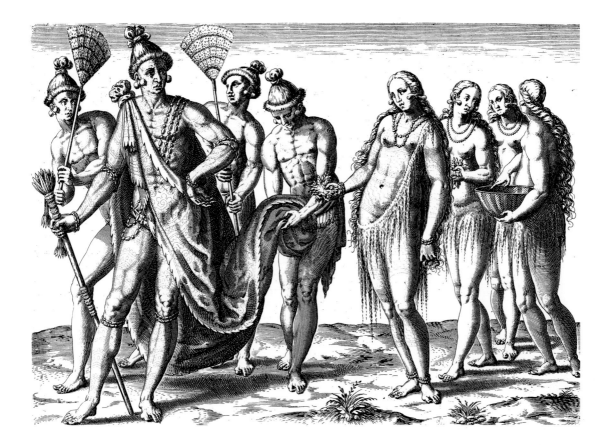

JACQUES LE MOYNE DE LA MORGUE, *THE KING AND QUEEN'S
EVENING WALK*, engraved by Theodor de Bry, 1591.

*Jacques Le Moyne's watercolors of Native Americans in Florida
were painted while a group of French Huguenots attempted to
establish a colony on the St. John's River in 1564. Le Moyne's
detailed, balanced paintings emphasize both the orderly
complexity of natives' social life and their savagery in war.*

7

theatrical and wildly unrealistic some of the pictures were, they seemed to recall a lost innocence in North America. These representations of a people seemingly living in a pre-European conquest state, an Adamic state in the subconscious religious sense, satisfied a profound curiosity by taking viewers back to the time-out-of-mind vanished past of humankind's forebears.

To us, the photographs reveal something of the values of the photographers and their customers. They are perspectives on what is often termed, not without irony, "Ethnic America." Social and political moments with deep roots in time, they leave out unpleasantries that almost certainly would have annoyed the mass market audience for whom they were intended—American and European bourgeois consumers.

Because these photographs do not stand alone, even in contemporary time, this introduction is wide-ranging in time and in its comparison of artistic traditions, a dialogue with an exotic past and its recorders, based on outstanding, often overlooked remnants of the past in the Library of Congress collections. We view these photographs, consciously or unconsciously, against a background of legend, myth, and history that predates even Columbus' first observations of Native Americans. At the same time, we view them against a background of more recently painted, printed, lithographed, or engraved images of what we have called Indians.

Most books dealing with photographs of Native Americans emphasize either their artistic value and aesthetic appeal or their historical accuracy and anthropological content. Some works put the Indian photographers within the context of the general history of American photography. I have attempted in addition to investigate the deep structure that lies behind the photographs we present and, in the light of this, to give them a modern reading—to hold conversation with them across time. My focus, I hope, will not only inform readers, but demonstrate the vast cultural richness of the Library of Congress.

I

First, because Indian photographs are not simple images, let us turn to their deep structure, their roots among the archetypes of the European imagination. These images have a thousand sources. Nineteenth-century photographers practiced their new art in an age which read the classics, compiled dictionaries of mythology, and admired history so much that it held a "World's Columbian Exposition" in Chicago in 1893. Thus, every photographer's mental baggage included a large inheritance of classical and romantic imagery.

Much of this imagery dated back to the revival of classical aesthetics in the Renaissance and had been recycled in painting and writing since the first encounters between European explorers and Native Americans at the end of the fifteenth century. Throughout the long period of European discovery and expansion, native peoples evoked an ambivalent welter of responses among Europeans—and later, among European Americans. Despite biblical chronicles about the dispersal of the descendants of Noah in Genesis 10, Greek myths about the lost continent of Atlantis, and medieval travelers' tales about the glorious realm of Prester John somewhere near the Mountains of the Moon, Europeans were surprised and bewildered in their first confrontations with

the New World and its peoples.

Columbus was disappointed in the weakness of the natives he first saw, though he later told of Amazons and men with tails. Dr. Alvarez Chanca, who sailed on Columbus' second voyage, was struck by the natives' "bestiality" and their "idiotic" habit of tattooing themselves—a practice that fascinated Captain James Cook in New Zealand centuries later. Nicolo Scillacio, who also sailed on Columbus' second voyage, drew a line between natives and cannibals. The latter not only lusted after the natives' wives, but captured and castrated their children, fattening them up so that they could be "eaten like capons." Michele da Cuneo, another veteran of that voyage, confirmed the cannibal practices of the natives, but was more fascinated with their sexual habits. "They copulate openly," he wrote, but they are "not jealous." Centuries later, Bougainville noted this habit in Tahiti with satisfaction. He named the island paradise "La Nouvelle Cytheria," after the Greek island of Cythera, where an important temple to Aphrodite stood in ancient times.

Europeans not only marveled at native peoples' sexual practices, but responded excitedly to their nakedness, their sheer physicality. The Portuguese explorer Amerigo Vespucci, for whom the New World was named, recorded that he deliberately shared the South American cannibals' lives for twenty-seven days, making him one of the earliest of field anthropologists. On the island of Curacao, he and his men attempted to capture seven Amazon women "a handspan and a half taller than any of the Europeans present." Vespucci thought that his king would enjoy them, but he was caught in the act of subduing these giant women by ten giant men. He desisted. Antonio Pigafetta, sailing with Magellan through Cape Horn via Patagonia, also confirmed the existence of giants, firmly establishing a legend that lasted nearly five hundred years.

While explorers recorded marvels, scholars looked to Europe's past to explain the origins of these disturbingly natural people. Peter Martyr, the sixteenth-century Spanish chronicler, was blasé about the claims of the explorers whose observations he compiled. He claimed that the writers of classical antiquity had recorded it all, including tales of Amazons like those Vespucci encountered.

Indeed, some shreds of the books of antiquity may well have *inspired* the tall tales told of these new people. Greek myths were peopled with monsters: the one-eyed Polyphemus; the snake-haired Medusa; the Chimera, "a fearful monster, breathing fire," part lion, part goat, and part dragon; the centaurs, half man and half horse; the nine-headed Hydra; the Harpies, man-torturing birds with women's faces; and the sirens, women whose sweet voices and faces enticed men to their deaths.

Echoes of these mythical figures could be found in the chants and tales of New World shamans and in Native American testing ceremonies such as the snake dances of the Southwest and the sun dances of the northern plains—which would be copiously photographed by late Victorian photographers. In the forests of both North and South America, tales of headhunters and half-human, half-monstrous cannibals fascinated whites well into the twentieth century. One of Edward S. Curtis' most famous photographs pictures a wild "hamatsa" figure or legendary cannibal dancer from the Kwakiutl tribe of the Pacific Northwest (see page 107).

Other European interpreters of New World peoples took a different, and puzzling, tack. Perhaps, declared readers of the New Testament, the natives were descendants of the Twelve Apostles as they spread about the world. These kinds of observations, together with the reports of Hernan Cortez, Conquistador of

Mexico, that the sixteenth-century Aztec city of Tlaxcala was "much bigger and stronger than Granada" and that Temixtitlan was "as big as Seville and Cordova" confused the savants as well as the clergy of Europe.

Were these native people in fact descendants of Adam and Eve, or Noah, or Abraham, the Old Testament redeemer? Were their cultures reminiscent of paradise, or their cities the sister cities of Plato's lost civilization of Atlantis or the Island of Brazilia? Had some peoples remained virtuous all through the Dark Ages following the fall of Adam and Eve? Some of the Indian photographers in this book would have us believe so, especially Frederick Monsen, whose naked Pueblo children clearly evoke the innocence of paradise (see pages 124-25).

Or had the natives simply degenerated into bestiality as a result of original sin? Was their "primitive," "savage" state the "badge of lost innocence?" Were their unselfconscious nakedness, their sexual habits due to lack of development after being cut off from emergent "civilizations?" Some of the images in our collection imply this nineteenth-century Christian point of view (see, for example, pages 67, 100, and 106).

At the turn of the century, the idea of emergent civilizations had become Darwinian and evolutionist, not biblical, but the subtle belief in the superiority of white peoples' progress is evident in many photos of native squalor and portraits implying native naiveté (see pages 52, 53, 54, and 116). In others, however, the Indians resemble creatures who have come directly from the hand of God. Their poses reflect the naked, ruined, or heroic statues scattered throughout Greece and Italy—as if the photographers subconsciously felt their influence, however faintly (see page 67). Or perhaps the photographers even suspected, like their Renaissance predecessors, that the statues were dim copies of a primordial people, newly rediscovered in Columbus' time.

This debate over the origins and history of Native American peoples has persisted through much of European and United States history, only fading with the emergence of modern anthropology. Even now, many people think about Native Americans in largely romantic or classical terms, despite a century of efforts by scientists and anthropologists to dispel what is often a subconscious association between the Indians and the "Ancients." The legends of New Mexico's Anasazi say that they are the New World's original people. And, despite all our knowledge of prehistory and the mammoth hunters, it seems we want badly to believe them.

Sometimes it seems that in the European tradition, Native Americans as observed by whites have never been real, that they have always been what the contemporary French philosophe Jean Baudrillard terms American "simulacra," or mere replications of the real thing. In many ways, this latter point—the persistence of illusions about Indians—is what this book of Native American photographs is all about.

II

Conjectural illustrations of Native Americans began to appear in Europe as early as 1493. A lascivious illustration entitled "Wild Naked People, Previously Unknown," appeared in a 1509 German translation of Amerigo Vespucci's letters to his Italian boyhood friend Pier Soderini, first published in Italy in 1505-06.

The first relatively accurate representation of a Native American, according to art historian Hugh Honour, appeared in a Portuguese painting dated 1505, *The Adoration of the Magi*. Jacques Le Moyne's grisly drawings of North American natives, engraved by Theodore de Bry for his monumental series on European explorers, have been widely copied and reproduced since they were first published in 1591. So, too, have John White's exquisite watercolor renditions of Native Americans as classical figures, also included by de Bry in his series. White once dwelt in the tragically lost colony of Roanoke, but escaped on the last ship out in 1587. When Native Americans visited colonial cities or traveled to Europe, their portraits were sometimes painted. The portrait of Pocahontas, the Indian wife of Virginia colonist John Rolfe, is the most famous of these and was painted in England in 1616, with Pocahontas dressed in fashionable English clothes signifying her then "civilized" state.

Interestingly, the Spaniards of the "Golden Age" of Cortez's conquests did not make portraits of native South Americans, though Columbus sent some two hundred natives back to Spain from Hispaniola. The Spanish artists were undoubtedly influenced by the Roman Catholic Church's view of infidels and advised by the church to concentrate on painting monarchs, saints, and popes. Fray Bartolomew Las Casas, in his famous debate over the humanity of the Native Americans with Juan de Sepulveda in Valladolid in 1550-51, did not even have accurate pictures to show either the Spanish King's tribunal or the Pope's ecclesiastic representatives. Nonetheless, the humanity of the Americans, so vociferously argued by Las Casas, was decided in the natives' favor by King and Pope on purely theoretical grounds. The Americans were thus a religious and legal hypothesis—a chimera of the European imagination.

III

Soon after the Revolution of 1776, the young United States took form with such suddenness that, thanks to Thomas Jefferson's Louisiana Purchase of 1803 and John Quincy Adams' Transcontinental Boundary Treaty of 1819, the native peoples of the Trans-Mississippi country became a curiosity to eastern Americans— just as they had been to Europeans centuries before. Lewis and Clark's 1804-06 expedition to the Pacific and the many tales of Indian traders added to this curiosity even more. Who were these ancient peoples of the plains, mountains, and deserts? Were they like the natives conquered by earlier generations of whites east of the Mississippi? What could be expected of them? What did they look like? They were still a mysterious "other," to use Edward Said's term.

One of the first Americans to systematically address the new nation's burgeoning curiosity about the native peoples whose cultures they were about to destroy was Thomas L. McKenney, United States Superintendent of Indian Trade under President Monroe. Beginning in 1821, McKenney commissioned dozens of portraits of Native Americans from Charles Bird King, a Washington, D.C. portraitist, and James Otto Lewis, who operated out of St. Louis under the aegis of William Clark, governor of all the territories from the Great Lakes to the Upper Missouri and the Rocky Mountains.

Charles Bird King's paintings, over one hundred of them, formed Colonel

McKenney's Washington "Indian Gallery;" hung side by side, the portraits crowded his office walls. McKenney had them painted because he wished to preserve for posterity the appearance of the most powerful western chiefs who came in delegations to bargain with "the Great White Father" over their own tribal lands. King and McKenney were among the first to recognize these proud, gorgeously plumed chiefs as "noble savages."

To preserve the Indian Gallery, McKenney transported his paintings from Washington to Philadelphia beginning in 1828, and then, in a "great national undertaking" encouraged by former president John Quincy Adams, he published the classic *History of the Indian Tribes of North America* (1834-1844), in three volumes, complete with histories of the chiefs and their tribes by the distinguished frontier jurist James Hall. McKenney thus illustrated for a mass market all of the patriot chiefs who came to Washington. These lithographs were common in nineteenth-century homes when the first generations of professional photographers were coming of age.

McKenney's quest to preserve a record of the grandeur of America's endangered peoples was soon seconded by an even more ambitious project. After seeing an Indian delegation in 1828 in Philadelphia, a minor portrait painter named George Catlin decided to devote his life not only to the cause of the Native Americans but to delineating their portraits, dwellings, customs, and habits. He would become, he declared, the historian of a vanishing people who had no one of their own to record their history. Given McKenney's heroic efforts, this was a slight exaggeration. In any case, from 1830 onward, Catlin spent his life painting the native peoples of the Western Hemisphere.

At first he painted the Missouri River tribes, then the southern Plains tribes, then the Minnesota and Wisconsin tribes. In doing so, he too assembled a large "Indian Gallery" which he repeatedly tried to sell to the United States government. In 1841, he published *Letters and Notes on the Manners, Customs and Conditions of the North American Indians*, so replete with illustrations that it became a kind of reference book. It still is for modern filmmakers. Then, in 1844, the London firm of Day and Haghe brought out a portfolio of forty-four lithographs of his paintings of Plains Indians. It would also become influential, especially since Currier and Ives pirated the images and sold them individually in large quantities throughout the United States.

In 1833, a 23-year-old Swiss artist named Karl Bodmer traveled to the United States with Maximilian of Wied, a German prince who wanted to practice the romantic anthropology he had learned from Professor Johann Bluhmenbach at Goettingen. In the fall of 1833 and winter and spring of 1834, they traveled on the Missouri River, studying the tribes who lived near forts and trading posts. While the Prince compiled a set of notes that came to total over 400,000 words, Bodmer painted the natives in portraits and genre scenes whose beauty and accuracy have never been matched. The Prince believed the Mandans to be descendants of blue-eyed Prince Madoc of Wales, who sailed west over the Atlantic in 1170. But his own researches and Bodmer's accurate paintings disabused the Prince of this idea—one as fantastic as those the earlier Spaniards had concocted. Bodmer's work is worthy of our attention because his impulse was to record ceremonial scenes and portraits that very much foreshadow the posed views and subjective interpretations of later Indian photographers, and even today's photography of primitive peoples in magazines such as *National Geographic*.

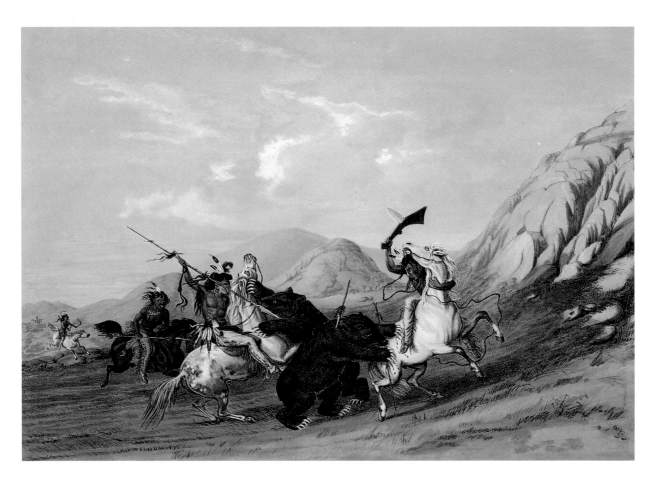

GEORGE CATLIN, *ATTACKING THE GRIZZLY BEAR*, lithographed
and handcolored by Day & Haghe, 1844.

*Catlin was an extremely rapid draftsman and made thousands of
rough sketches and watercolors in the field as he traveled among
the Plains tribes. For his series of lithographs, however, he
assembled elements from his fieldwork into deliberate, sometimes
unconvincing compositions.*

KARL BODMER, *FORT McKENZIE, AUGUST 28, 1833*, engraved and handcolored by Bougeard, 1842.

Like Catlin, Bodmer assembled and composed his engravings from field sketches and watercolors. To dramatize the savagery of an Indian battle for his European audience, he has adopted a perspective amid the action; in fact, he watched the battle from inside Fort McKenzie.

14

Ordinarily in a book on Native American photography one does not need to know much about McKenney, Catlin, or Bodmer. Our purpose, however, is not simply to catalogue Indian photographs and photographers, but to look at how white Americans' perceptions and preconceptions shaped the visual records they made of Native Americans. This is, in Professor Alan Trachtenberg's fashionable term, a "reading" in the modern manner of an outstanding collection of photographs. As such, it must take into consideration previous conventions in the illustration of the Indian. Though photography was a new medium, earlier images, expecially mass-distributed prints, had an important effect on photographers. Stereotypes tend to persist.

Stunning and often accurate renditions that they were, paintings, drawings, woodcuts, and lithographs of Native Americans did not reveal the "real" Indian. Perhaps this is one reason the United States government and the Smithsonian Institution did not purchase Catlin's works. Noble savage sages could be represented on the pediment of the United States Capitol and in statues by sculptors such as Thomas Crawford, but to frontier families, fur trappers, and overland pioneers, Indians were brutal murderers who need not be celebrated. Worse still, along with the loss of Native American lands and the deterioration of their cultures, alcoholism spread among the tribes, and drunken Indians became a common sight in trading posts and towns throughout the West. They were objects of contempt even to the missionaries who supposedly came to help them. Thus they were, in a sense, deromanticized in the eyes of those who had only partial glimpses of what had been powerful and subtle cultures.

Europeans, however, continued to regard Native Americans as exotic peoples—an irresistible icon for the Romantic movement. To this day, European museums' Native American collections are typically far better than Anglo-American or Hispanic American ones, and the Indian remains the most romantically potent symbol of America. German author Karl May's literary Apache Winnetou, hero of Germany's best-selling books of all time, also rides forever on German television.

IV

The apparent objectivity of the photograph makes us consider the question of the "true" Indian in a new way. Has photography deromanticized and demythologized the Indian or not? Has photography portrayed the scientized, ordinary Native Americans of folkways anthropology rather than the handsome, beautiful, or fearsome braves and squaws of popular culture? Or have photographers, like many of the early anthropologists, focused on the exotic, the picturesque, the mysterious, and the dramatic?

The process of photographing the natives began in the early 1850s, first with daguerreotypes, then with wet-plate cameras and stereograph or "3-D" cameras. It was not until the late 1880s that paper, then celluloid film, came into use, thus allowing a very few candid photos of the Native American. By then, it was almost too late to document intact, coherent Native American cultures.

According to photo historians Paula Fleming and Judith Luskey, the first daguerreotype of an Indian was taken in England. The subject was the Reverend Peter Jones, known sometimes as Kahkewaguonaby, the son of a Welshman and a Native

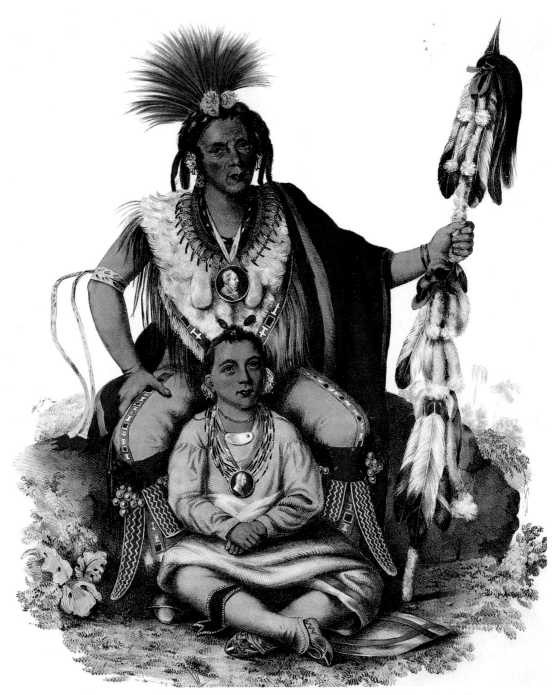

CHARLES BIRD KING, *KEOKUK, CHIEF OF THE SAUCS AND FOXES*, lithographed by J.T. Bowen, 1842.

"Keokuk is, in all respects, a magnificent savage," wrote James Hall in the text to Thomas McKenney's great project. "Bold, enterprising, and impulsive, he is also politic, and possesses an intimate knowledge of human nature." King's portrait, painted in 1837, suggests the high regard in which whites held this chief.

American woman. The portrait emphasizes his noble appearance. Another very early daguerreotype was Thomas A. Easterly's portrait of the Sauk and Fox chief Keokuk—a view of a stern, frightened person, very different from the well-known seated portrait painted by Charles Bird King and lithographed for McKenney and Hall's *History of the Indian Tribes of North America*. Painted in 1837 when Keokuk was at the height of his power, King's portrait presents him as a ruler in his prime, seated on a throne with his young son between his knees. With his warrior's lance and strong, benevolent expression, this Keokuk evokes an enthroned Zeus—a tribute to Keokuk's recognized authority and large Washington delegation. Indeed, McKenney admired Keokuk above all other chiefs who came to Washington.

Easterly's daguerreotype, probably taken in Rock Island, Illinois, in 1847, one year before Keokuk's death, painfully reveals his subsequent degradation and bewilderment. Easterly's Keokuk has the same spiked hairdress as King's, but around his neck he wears a prosaic bandana instead of festive garlands. He retains his peace medal and bear-claw necklace, but no longer has his furs or his warrior's lance. Little is left to romance in this matter-of-fact portrayal of an aging native man who has lost his power to the white invader.

In 1851, George Catlin's dancing Ojibwa, with whom he had given Indian shows in London and Paris, were photographed in all their stately glory upon their return from Europe. Beginning in the early 1850s, too, the delegations who traveled to Washington were photographed rather than sitting for days before a painter. Cheyenne, Arapaho, Blackfoot, Lakota (Oglala, Yankton, Brule, Melewakanton, and Santee), Crow, Chocktaw, Sauk and Fox all posed for the "magic box." One lucky Cheyenne, Man on a Cloud, was even daguerreotyped with the celebrated danseuse Lola Montez, the rage of the Gold Rush mining camps. Others in group photos lounged on the steps of the White House. Some wore native costumes. Others were clad in elegant European tailored clothes.

These government-sponsored Bureau of Ethnology photographs, now on file at the Smithsonian Institution's National Anthropological Archives, form an important part of our photographic record of Native Americans. But since most of these images were taken for documentary and anthropological purposes—the War Department, for example, had

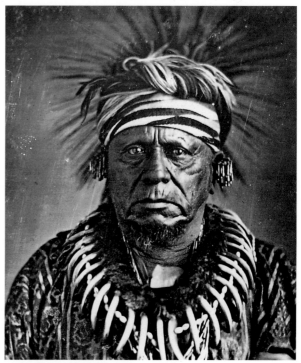

THOMAS EASTERLY, *KEOKUK,* 1847 (courtesy National Anthropological Archives, Smithsonian Institution).

The Smithsonian's copy of Easterly's daguerreotype is a wet-plate negative made by Washington photographer Antonio Zeno Shindler in 1868.

the sinister motive of recording chieftains' likenesses in case war broke out—they were not usually sold commercially and were not, therefore, submitted to the Library of Congress for copyright.

Another important group of nineteenth-century Indian photographs which cannot be represented here comes from the collections of the Bureau of American Ethnology, now in the care of the Smithsonian Institution. These holdings include the work of such recognized masters as William Henry Jackson, Jack Hillers, E. O. Beaman, and Timothy O'Sullivan, photographers who accompanied the four major post-Civil War government surveys of the West or contributed to later researchers there, and ethnologists DeLancey Gill, James Mooney, Alice Fletcher, and Matilda Coxe Stevenson, who photographed or hired photographers to record images for documentary purposes. Although geography, geology, and resources were uppermost in the surveyors' minds, they duly recorded Indian pueblos, Anasazi ruins, and numerous natives in "typical" situations. Landscapes such as O'Sullivan's sweeping views of Canyon de Chelly, New Mexico, with its exquisite Anasazi ruins, became photographic classics.

The Bureau of American Ethnology, the first American institution for the study of primitive cultures, was itself a direct result of these surveys. John Wesley Powell, leader of several expeditions on the Colorado River and the surrounding plateau country in the 1870s, founded the B.A.E. after witnessing Native Americans' desperate situation in these territories.

As he put the case of the Native American before Congress and the nation, Powell made use of his survey photography, much of it taken by Jack Hillers with the assistance of artist Thomas Moran.

V

Like the Hillers-Moran approach, our collection of Native American photographs begins with the concept of the photogenic. That is, most of these images were intended to represent Victorian aesthetic notions of beauty, grandeur, or the picturesque, as well as the dominant sentiments of Victorian popular art—pathos, exoticism, and irony. Virtually all of the photographs in this collection were posed and composed like works of art. Just as Theodor de Bry, three hundred years earlier, imbued his Native American figures with the postures and proportions of Renaissance classicism, the photographers who made these images consciously or unconsciously applied the conventions of European romanticism.

The story of these photographs is also closely intertwined with the early history of American movie-making. From the beginning, in the 1890s, American filmmakers were drawn to the West, converting the most recent chapter in the nation's history into docudrama almost before it had ended. In 1913, in fact, the United States Army's General Nelson Miles teamed up with Buffalo Bill Cody to make *Indian Wars Refought*, a lengthy film recreation of the major battles between the Army and the Plains Indians. Sadly, only snippets survive of this remarkable project. Soldiers from the U.S. Army participated, as did many Native

American battle veterans and their descendants. Cody, of course, was the star. But tensions ran high. When the filming of the Wounded Knee fight took place, a number of the Sioux were found to have real bullets in their guns.

From the first, the two-reel western melodrama made the Indian heroic, because it brought no glory to conquer a weakling foe. Photographers—some of whom made stills for these movies—rapidly imitated the movies' nobilizing style. The three greatest early filmmakers were "Broncho Billy" Anderson, the first cowboy hero, D.W. Griffith, better known for *Birth of a Nation,* and Thomas Ince, who merged his Bison Films with Oklahoma's 101 Ranch Wild West Show and created "Inceville," a community in the Santa Monica Mountains which included a whole Ponca Indian village and became Hollywood's first mass production movie company (see page 46). Ince made eight hundred western films in his relatively brief career, directing early cowboy actor William S. Hart in virtually all of his popular films and pioneering the pro-Indian genre in titles like *The Honor of the Tribe, An Indian Martyr,* and *An Indian's Honor.*

"Broncho Billy" Anderson, who played in the world's first feature movie, *The Great Train Robbery,* followed this up with hundreds of films from his Essanay Company. One of his most impressive efforts was *The Indian and the Child,* filmed in sepia. This deeply sentimental film tells the tale of a squaw whose babe has been killed by white men. Nonetheless, she rescues a white woman's captive infant from her tribe and returns it to its mother. The film's sepia coloring and romantically posed scenes unmistakably reveal its relationship to Edward S. Curtis' photographs, which were beginning to reach the public at the same time.

D.W. Griffith's many Indian films, such as *The Red Man and the Child, Comata the Sioux, Ramona,* and *The Squaw's Love,* must also have influenced still photographers. And Mona Darkfeather, a Native American herself, made more than fifty films featuring Indian heroes and heroines, including *The Return of Thunder Cloud's Spirit, The War Bonnet, The Coming of Lone Wolf, Grey Eagle's Revenge,* and *The Indian Suffragette.*

Tom Mix, too, was famous for his Indian films, but the vast majority of early westerns which included Native Americans made them noble but savage foes. Thus, for the still photographer of the time, convention dictated two Indian types: the vanishing American or the warrior. The Native American remained the "other."

VI

Many of our photos were taken by the greatest romanticizer of all, Edward Sheriff Curtis. Curtis started out as a local Seattle society photographer. He became interested in Native Americans after being hired as principal photographer on railroad tycoon Edward H. Harriman's 1899 expedition to Alaska, and he spent the ensuing thirty years photographing most of the existing tribes of North America. He explicitly saw himself as the George Catlin of photography. This enterprise, first encouraged by George Bird Grinnell on the Harriman expedition, began on the Blackfoot reservation in August 1899. For seven years, Curtis financed his project alone; after 1906, it would be bankrolled by that other notorious commodifier, J.P. Morgan. Curtis established a photographic and publishing industry that lasted some twenty-six years under the Morgan aegis, supported first by the father, then by the son. Curtis' enter-

prise was signaled by his proud letterhead: "The North American Indian, Publications Office, 437 Fifth Ave., New York."

Curtis the Indian photographer first came to public notice when he submitted three photos to the National Photographic Exhibition and won the grand prize for a soft-focus sunset picture of an old Indian lady digging clams out of the mud flats of Puget Sound. That old lady turned out to be Princess Angelina, the pathetic, poverty-stricken, toothless daughter of Chief Sealth, who had sold the white man the land upon which Seattle now stands—a city named, appropriately, after a corruption of his name. Curtis subsequently won prizes in many countries—including a solid gold medal—with these pictures, which some say were either suggested or actually taken by his friend D.J. Inverarity.

The pictures were published in soft-focus sepia, which became Curtis' romantic trademark. This technique undoubtedly stemmed from his Seattle studio work on weddings and flattering society portraits, of which he was such a master that he captivated New York's elite Four Hundred with a show at the Waldorf Astoria. Their interest in the flattering sentimentality of Curtis' work indicates something of the upper-class mindset in the early twentieth century. In 1904, Curtis was the official photographer for Theodore Roosevelt's inauguration. Among the inaugural celebrants, coincidentally, he met the doomed Geronimo. Roosevelt invited Curtis back to the White House in 1906 to take his daughter's wedding pictures. Pleased with the results, Roosevelt gave Curtis the letter of recommendation to J.P. Morgan that led to the financing of Curtis' project.

For the most part, as our examples indicate, Curtis dealt in pathos and sympathy for the "vanishing American," the title of one of his most famous pictures. Curtis seemed to get on well with the natives, though sometimes they threw dirt in his camera and even shot at him. He told a reporter, "An Indian is like an animal or a little child....They instinctively know whether you like them—or if you are patronizing them. They knew I liked them and was trying to do something for them." Later, in 1911, he explained to a *New York Times* reporter, "They have grasped the idea that this is to be a permanent memorial of their race, and it appeals to their imagination. Word passes from tribe to tribe....A tribe that I have visited and studied lets another tribe know that after the present generation has passed away, men will want to know from this record what they were like, and what they did, and the second tribe doesn't want to be left out." Moreover, in addition to taking their pictures, like George Catlin seventy years before, Curtis collected their songs and legends and biographies. He had three advantages over Catlin, however: Edison's recording machines, translators, and a stenographer who knew shorthand. But recent research by Mick Gidley of Exeter University in Great Britain indicates that in some tribal regions, ethnological "brokers" such as the Hubbells, pioneering Indian traders in the Southwest, sold costumes to Curtis and programmed the natives to tell the photographer what he wanted to hear. The Navajo were even instructed to conceal their sacred dances from Curtis by deliberately conducting them backwards.

However, Curtis was not invariably duped. He was, in fact, the only white man ever allowed to participate in the nine-day Hopi Snake Dance. As for the Hubbells, they went on to play the same tricks on anthropologist Clyde Kluckhohn much later, after which he wrote what he and the anthropological community thought was the definitive work on the Navajo.

As Curtis got into his mighty project, the emergent corps of professional

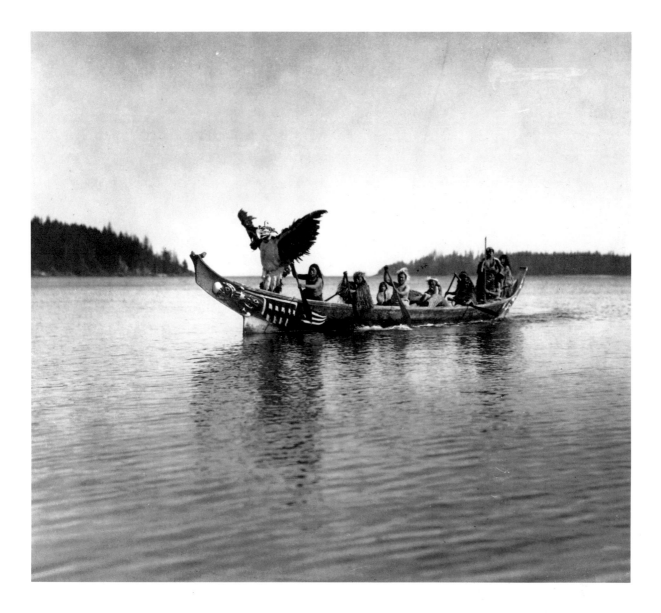

EDWARD S. CURTIS, *COMING FOR THE BRIDE—KWAKIUTL,* © 1914.

Curtis took this photograph as a still for his movie In the Land of the Headhunters. *Performed by the Kwakiutl, a Pacific Northwest tribe, the movie was based on Shakespeare's* Romeo and Juliet.

anthropologists began to object. Led by Franz Boas, they flatly asserted that his methods were "unscientific," especially since he was trying to portray the Native American in his preconquest state. Christopher Lyman's recent book, *The Vanishing Race and Other Illusions*, clearly shows that Curtis doctored and posed his photographs for archaic and dramatic effect—he engaged, in a sense, in creating Baudrillard's simulacra. Readers should be aware of this, but they should also know that Curtis' great models, the artists Catlin and Bodmer, also did the same thing, with the same intentions—preserving the memory of a vanishing race. And Curtis did extensive research to capture the feeling and look of the preconquest tribes. Boas and the so-called "professionals" themselves were hardly objective or accurate. We know that objectivity in the social sciences and even history is, in historian Charles Beard's words, only a "noble dream."

Nonetheless, Boas and his crowd demanded the creation of a committee to look into the validity of Curtis' enterprise. Even President Roosevelt, an early enthusiast for the project, called Curtis to inform him that he had received "a complaint from a professor at Columbia University"—clearly Boas, who fancied himself the dean of American anthropologists even at this early date in the development of the discipline. Ignoring the fact that Boas' degree was in physics, not ethnology, Roosevelt informed Curtis, "Because you do not have a formal degree in ethnological research they question the validity of your work." Roosevelt added, "I have appointed a committee of three men whom I consider supreme authorities in our country to go over your work and render a decision."

The three were Henry Fairfield Osborn, curator of vertebrate paleontology at the American Museum of Natural History; Charles Doolittle Walcott, secretary of the Smithsonian Institution; and William Henry Holmes, chief of the Bureau of American Ethnology. Only Holmes had the faintest knowledge of Curtis' subject, and he positively hated Boas—even blocking his appointment as head of Chicago's new Field Museum. But these three men represented the scientific establishment in the United States. They had nothing but high praise for Curtis' work, and Roosevelt ended up writing a glowing introduction to the first volume of *The Indians of North America*.

Meanwhile Curtis had another check on his work. Frederick Webb Hodge, editor of the official *Handbook of American Indians North of Mexico*, was appointed to edit Curtis' chapters. Ironically, their manuscript correspondence indicates that Curtis and Hodge became fast friends and mutual admirers of one another's work. Curtis was happy to check his facts and findings with Hodge. In turn, Hodge welcomed the information pouring in from Curtis' vast fieldwork—fieldwork so extensive that it dwarfed anything Boas or any other American anthropologist has ever done. Even one of the "professional" anthropologists, Dr. William Curtis Farabee of Harvard, wrote in *The American Anthropologist*, "The author [Curtis] has succeeded admirably in his endeavor to make the work one which, in fact, cannot be questioned by the specialist but at the same time will be of the greatest interest to the historian, the painter, the dramatist and the fiction writer as well as the ethnologist."

By 1930, Curtis' great work was done. Volume 20 went off to the printer, and the rest of his life was understandably an anticlimax. He became the still photographer for Cecil B. DeMille's biblical epics. He had made 40,000 pictures of Native Americans, written and produced 20 large volumes of commentary, and compiled a matchless research archive that made Hodge's *Handbook of*

American Indians North of Mexico possible because of the opportunity for cross-checking with the avalanche of Curtis' field notes.

According to Curtis' daughter, the late Florence Curtis Graybill, whom I interviewed in 1980, Edward Curtis loved the Native Americans, and he could be belligerent in defending them. He was a true intellectual descendant of George Catlin. It is well to keep this in mind when viewing his seemingly romanticized pictures. Their meaning, full of late Victorian sentiment, far transcends even their value as ethnology—as do most of the photographs in this book. Among the North American Indians, Curtis had found his "place of grace."

VII

Ever ambitious, Curtis ventured into motion picture photography during his great project and made *In the Land of the Head-Hunters*, the story of Romeo and Juliet acted out by the Kwakiutl Indians of Vancouver Island in a war between the Bear and Eagle clans (see page 21). His work inspired an early milestone in ethnographic filmmaking, Robert Flaherty's *Nanook of the North*. Stymied while trying to make his film on Baffin Island, Flaherty came to New York in April 1915, viewed Curtis' film, took his advice, and finished *Nanook*, which has been a classic ever since. Curtis' *In the Land of the Head-Hunters*, however, was largely forgotten until William Holm and George Irving Quimby restored it between 1967 and 1974.

Even before Curtis made his ethnographic masterpiece, Rodman Wanamaker, the Philadelphia department-store magnate, sponsored a number of photographic expeditions into the West intended to document the vanishing race. According to Fleming and Luskey, "the expeditions produced 11,000 negatives on glass plate and nitrate film and fifty miles of motion picture film. The film has deteriorated but the prints remain."

While Dixon was leading the Wanamaker expeditions, dozens of other photographers (many of whom are discussed in the picture captions that follow) moved into the West to supply the Indian photographs demanded by curious Easterners brought up on James Fenimore Cooper's Leatherstocking novels and Longfellow's *Hiawatha*, fans of Buffalo Bill Cody's Wild West Show, and disappointed tourists who saw fine hotels and beautiful scenery in the West, but no Indians.

It was fortunate that photographers sought out the Indians, because railroad promoters and guidebook publishers concentrated entirely on scenery and animals. George A. Crofutt's *Overland Tourist and Pacific Coast Guide*, the most popular of all guidebooks, mentioned the Indian only once, and then in derogatory terms. Other guidebooks generally touted sporting opportunities, the progress of civilization, and incredible scenery, which was characteristically compared with European landmarks.

The natives themselves avoided the main railroad routes, except in the Southwest, where Fred Harvey's restaurant, hotel, and tourist guide company supplied them as "entertainment" or conducted "photo opportunity" trips to the Hopi towns where the snake dances were held (see pages 31, 32, 33, 35, 112, and 113). In general, tourists were unimpressed with the Indians they saw. Anne

Farrar Hyde quotes two such travelers. One declared, "Those who expect to see the heroes, or their descendants, of Fenimore Cooper's novels, will be woefully disappointed." The other asked rhetorically, "Could these blear-eyed bedlams, crooning in a low discordant plaint, and stretching forth skinny claws for alms, be the sisters of Little Fawn or 'Laughing Water'?"

Thus the Native American commercial photographs featured in our collection first whetted the easterner's appetite for Indian scenes with images of things that didn't exist, and then perhaps made up for his disappointment by providing Indian pictures at the local photo gallery back home.

George "Ben" Wittick of Gallup, New Mexico, can perhaps stand for this host of freelancers who made a living out of the West and the Indian (see pages 33, 36, and 123). A veteran of the Civil War and the Sioux campaigns on the northern Plains, Wittick got his start as a western photographer on contract to the Atlantic and Pacific Railroad, or the Atchison, Topeka, and Santa Fe. In 1881, he set up the Blue Tent Studio in Albuquerque near the railroad line. As the tent implied, Wittick moved around the Southwest a good deal. He established a base at Gallup, then Fort Wingate, thirty-five miles northwest of Gallup in Navajo and Apache country, but he also took many scenes of Santa Fe, El Paso, Juarez, Las Vegas, New Mexico, and the pueblos of Jemez, San Felipe, Santo Domingo, Zuni, Acoma, Taos, and Laguna. As he made his way across the Southwest, Wittick managed to photograph such famous chiefs as Nachee and Geronimo. According to Van Deren Coke, the authority on New Mexico photography, Wittick's was not truly an artist's outlook, and his Indian "portraits rarely convey more than a glimmer of personality," though he wielded his wet-plate camera with workmanlike skill. Wittick also showed a kind of courage as he roamed the still hostile Southwest. He died of a rattlesnake bite while making photos outside Fort Wingate in 1903.

One of the products of his work, and of most of the other photographers in this book, were "cabinet cards" or "cartes de visite" which looked not unlike today's baseball cards, but featured portraits of famous chiefs and other Indians and typical pueblo scenes. He and others, especially Curtis, also made postcards. Wittick probably derived these not from his large wet-plate negatives, but from George Eastman's Kodak celluloid film camera that came out in 1889. Wittick and many other Indian photographers also employed a smaller stereo camera that gained a three-dimensional effect with binocular lenses set at slightly different angles. Stereo photo cards were also best-sellers, a middle- and upper-class families could not afford to be without a stereoscope viewer on the table. The worldwide scenes they portrayed were part of a middle-class education.

A final product of the Indian photographers' work were wood engravings, and later photo reproductions, which appeared in the pages of *Harper's Weekly, Harper's Monthly, Frank Leslie's Illustrated Weekly, Century, Outing,* and a large number of English and European illustrated magazines.

The rage for these Indian photographs and reproductions stemmed in part from the Euro-American's sense that Native Americans' lives symbolized American innocence, an illusion the pictures preserved even as railroads, railroad towns, mining boom towns, and the telegraph linked the West with white culture and its economy. Our knowing that these facts are just out of view in every picture adds a strongly poignant note to the images. Photographs of anyone's ancestors can be tragic, but they rarely symbolize such complete, destructive changes for an entire people and way of life.

Still another thread runs through our collection, the anthropological view. When these pictures were being taken, anthropology was just emerging as a field of study. At the same time, educated tourists were beginning to take an interest in native crafts, native customs, and native ceremonies—an interest spurred in part by the anthropologists. Commercial photographers came on the heels of the tourists, supplying them with postcard images for the folks back home and generating yet more interest in native ways. In a sense, by drawing so much attention to Indians, the early anthropologists may have hastened the deterioration of the native cultures they so treasured.

Art, early western movies, documentary film, anthropology, and reform propaganda all played their parts in influencing the photographers of Native Americans. So too did the lure of tourism, the only industry that ever tied the whole West together in a grand, inviting myth. Clearly these photos, from snake dances and pseudo-war parties to virgins making bread, were aimed at the tourist market. Wise young Marxists (however severely embarassed at present) correctly labeled this "the commodification of the West." Photographers were selling scenery comparable to the Alps, ruins (at the Anasazi pueblos) as intriguing as Abu Simbel, and the mysterious, temptingly exotic dances and customs of the "people of the first man," which seemed far stranger than the Old World's picturesque peasant cultures.

Many of the photographs in our collection reveal this process of commodification and, frequently, the Native American's eager participation in it. No railroads cross our photos, tourist palaces on the European model do not grace them, but they are there in a process some would call "insidious." Our pictures too are then "insidious," conspiratorial; beneath the veneer of primitivism must lie the very structure of capitalism. Certainly the photographers unabashedly embraced capitalism as they made their pictures for sale or under contract to captains of commerce such as Rodman Wanamaker and J.P. Morgan. Almost all of these photographers sold their pictures to the railroads, perhaps the most notorious of American Victorian business enterprises. The railroads represented the economic infrastructure that opened the West—Indian lands—to all those "tired, poor, weary" Eastern European and Asian people pouring into Ellis Island and San Francisco. So are these tourist photos moral? Are they, like the early Catlin and Bierstadt paintings, insidious agents of imperialism, an imperialism in which Frederic Remington, with his rough-hewn racist Darwinism, so unselfconsciously reveled?

Once upon a time, Herman Melville wrote to his friend Nathaniel Hawthorne, "I have written a wicked book and I feel as innocent as a lamb." Should we feel this way in presenting our sequence of pictures as we do? Should the photographers, those commodifiers, feel like Melville? Did they? Probably not.

VIII

To me, the most poignant part of this book is the long sequence of portraits, representing humanity itself in all its moods and manifestations, from crying babies and scornful children to proud warriors and men who clearly walked out of the stone age. In the 1930s, writer Erskine Caldwell and photojournalist Margaret

Bourke-White made a photo book which they called *You Have Seen Their Faces.* In our book, you will see their faces—American faces—in the American West.

The portraits are unmistakably, often stiffly posed. Their subjects sometimes wear fake costumes, supplied by the photographer. Nonetheless, the people we see are very much alive, very human. The first of the portraits, the contemplative chief Samuel American Horse, exudes the pride which we associate with the "noble savage" (see page 87). It also suggests a certain scorn for the white man which is echoed in the portrait of an Indian child on the following page. We sense a Jim Thorpe toughness and athleticism in one crew-cut warrior (see page 96). He is not complex. Chief Red Shirt seems to be arguing a point, somewhat like an irate shopper (see page 91). An Inuit lady laughs despite mutilated lips, all done for beauty, as she commodifies herself more thoroughly than Sinclair Lewis' antiheroine Myra Babbitt (see page 93). Hers is a genuine laugh, not a Sinclair Lewis parody.

And yet, inevitably, none of these commercial photographs is candid. They point to an interesting discovery, best highlighted by Edward Curtis' work, whom I have singled out and related to the anthropologists who criticized his artificiality. Almost no Native American photograph is really candid. Instead, they all reveal a new genre for photo historians and critics to study: the ceremonial. It is no accident that Curtis first made his mark by taking hundreds of group scenes and portraits at white ceremonies. It may even be that the taking of a photograph is so much of an event that ceremonial overtones are inevitable. In this photographic story, we start with an image based on Longfellow's pasturized Indian legend of the romance of Hiawatha and Minnehaha (see page 4) and end with Indians posed in a convertible car with three seats (see page 138), the whole family out for a "photo opportunity," perhaps, but not on Hollywood Boulevard. For these Indians, Hollywood collapsed into "the prosaic reality of Spokane."

Noble savages, too, will stand across the shining river contemplating their Kodaks and their tipis and the negatives they've taken of themselves, held up to the sun god: "shade of a shade, daguerreotype of a likeness," simulacra, Americans.

William H. Goetzmann
Austin, Texas

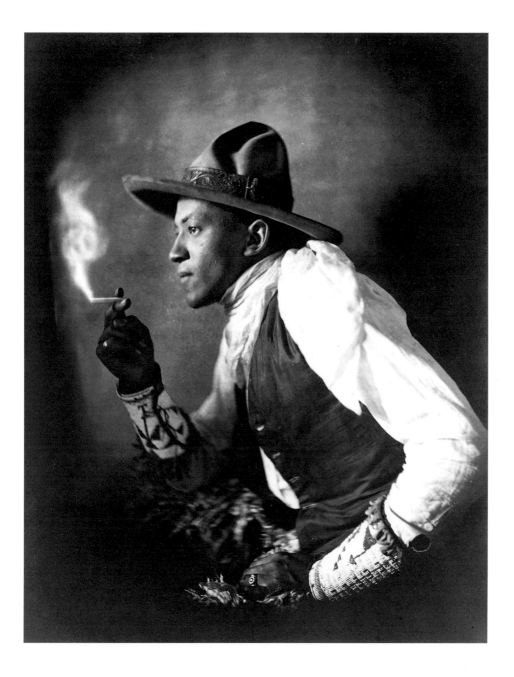

JOHN A. JOHNSON, *THE CIGARETTE,* © 1908.

*Johnson's Indian in cowboy gear says much about whites'
desire to acculturate Native Americans. The sitter was probably
from Pawnee Bill's Wild West Show, a rival of Buffalo Bill's.*

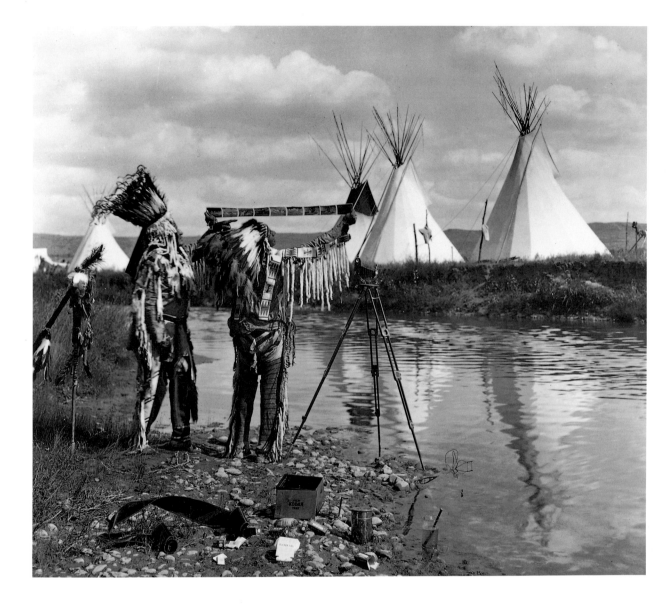

JOSEPH KOSSUTH DIXON, from the Rodman Wanamaker
Expedition of Citizenship to the American Indian, © 1913.

*In what is almost a mock sun-worshipping ceremony, Indians
in full Plains chieftain's regalia regard their white man's
handiwork. Few photographs more bluntly express the limits
of ethnographic photography.*

28

CEREMONIES

Though all of the photographs in this volume are in some sense ceremonial rather than candid or purely documentary, we begin with observations of actual Native American ceremonies. The first of these pictures ushers us into a strange, almost make-believe world, the world of sacred Pueblo dances, which were being commodified by cameramen and tourists at the turn of the century.

The snake dance of the Hopi fascinated white Americans. It was mysterious and incomprehensible to a generation of people for whom, perhaps because of the everyday clamor of industrial civilization, the occult was fashionable and the primitive was irresistible. Why, they wondered, do these natives defy death in such a ghastly way? The ceremony begins in the kiva, which represents the earth's core. For days, jars filled with deadly snakes are kept there, and the Snake clan lives with them before joining the Antelope clan in a dance above ground, paying homage to the spirits. Anthropologists tried to analyze it, photographers sold it, railroads touted it, Edward Curtis participated in it, and tourists swarmed to it until, as the photo of a Zuni Pueblo dance on page 36 suggests, the Zuni and the Hopi eventually had to make their ceremonies private, seen only (if at all) through a distant lens.

The snake dance would also contribute to the preservation of Native American culture in this century. In 1932, a tourist named John Collier saw the dance and became involved in a national campaign to reconstruct tribal life, which led to the "Indian New Deal" or Wheeler-Howard Indian Reorganization Act of 1934. The Act, among other things, affirmed the right of the tribes to govern themselves and gave them access to funds for education and land. Collier became the director of the Bureau of Indian Affairs, established to administer the Act.

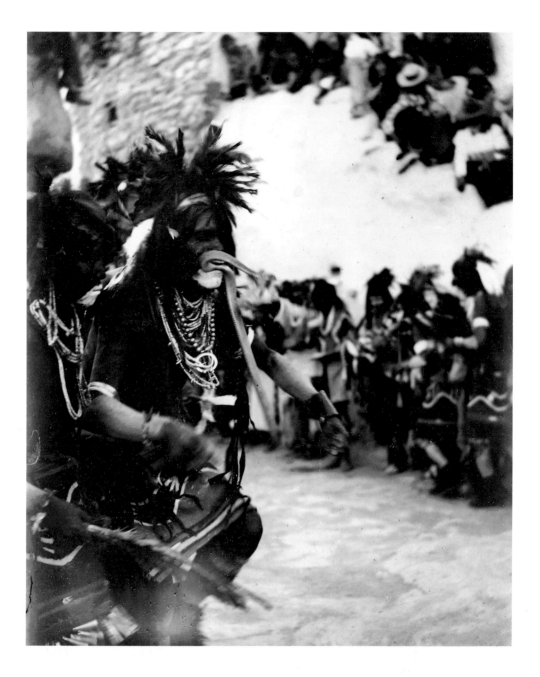

HARTWELL AND HAMMAKER, *HOPI SNAKE PRIEST WITH SNAKE IN HIS MOUTH IN THE HOPI SNAKE DANCE,* © 1899.

Tourists in search of primal Indian savagery found gratification in the snake ceremony, in which priests boiled up out of the underground kiva and began to dance with a variety of desert snakes, including rattlesnakes, rarely receiving fatal wounds. The photographer may be Jennie Hammaker, a missionary teacher at the Navajo town of Zuni in New Mexico.

31

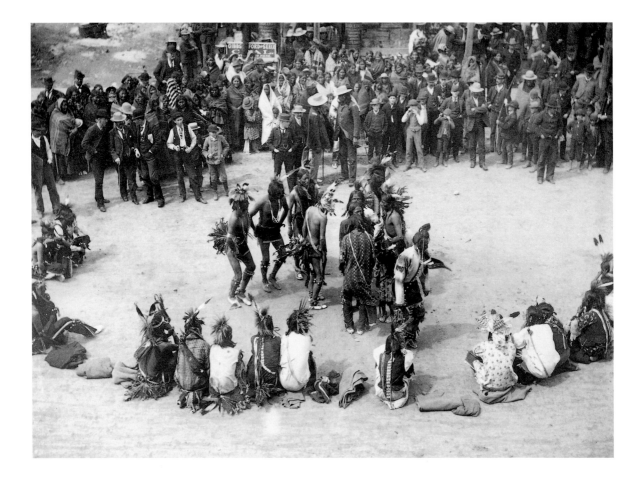

WILEY BROTHERS, *THE GREAT OMAHA POW-WOW DANCE OF THE
CHEYENNES IN MONTANA, APRIL 1891,* © 1891.

*The audience and setting in this photograph of a Cheyenne dance
before a crowd of whites on a street in Miles City, Montana typify what
happened to the Native American. Even at this early date, only fifteen
years after they defeated Custer, the "fighting Cheyennes" were reduced
to performing a pow-wow dance for tourists and local white settlers.*

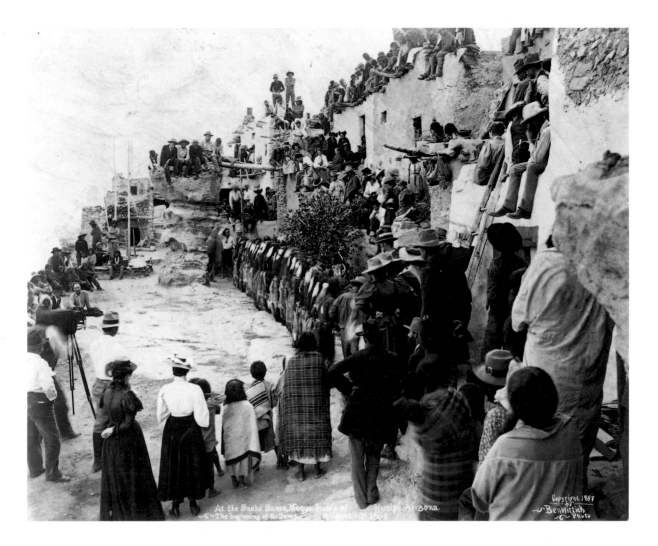

GEORGE BEN WITTICK, *AT THE SNAKE DANCE, MOQUI PUEBLO OF HUALPI, ARIZONA, AUGUST 21, 1897,* © 1897.

The biennial performance of the Hopis' famous snake dance alternates among the villages atop three sacred mesas. The sixteen-day ceremony, performed by the Snake and Antelope clans to bring rain, was first witnessed by whites in the 1880s and quickly became a sensational attraction. In 1897, some two hundred white tourists were in attendance, having come overland in wagons and buckboards. The ceremony was open to the public until 1971.

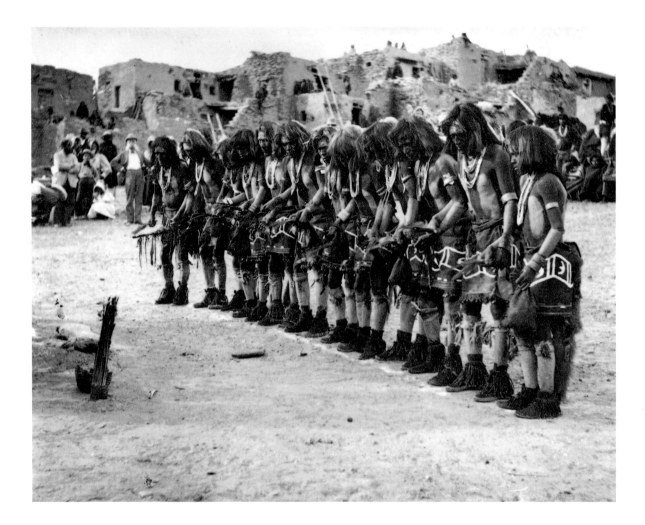

ADAM CLARK VROMAN, *SNAKE PRIESTS AT SNAKE DANCE*, © 1900.

*On the last two days of the ceremony, the Antelope and Snake clans
dance in the plaza, circling past the kisi, an altar of reeds and
cottonwood boughs, and the sipapu, a hole leading to the underworld.
After circling, the Snake men (shown here) chant in a line, holding eagle
feather whips. The snakes, which have been gathered north, west, south,
and east of the village on the first four days, stay in jars in the Snake
kiva until the last day.*

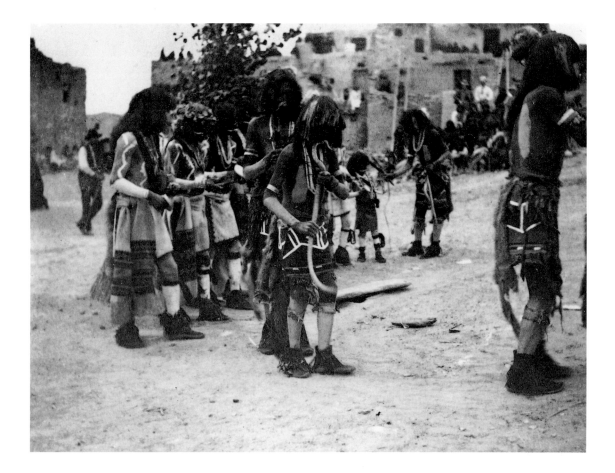

ADAM CLARK VROMAN, *CARRYING THE SNAKES,* © 1900.

On the ceremony's last day, the snakes are brought up in bags from the kiva and hidden in the kisi. As the Antelope men stand by the kisi (left), the Snake men enter from their kiva, circle the plaza, chant in a line, then leap toward the kisi, pull out snakes, and dance with them. "Huggers" follow behind, calming the snakes by stroking them with their whips. As the snakes are tossed about, sometimes falling to the ground, the Antelope priests join in catching them.

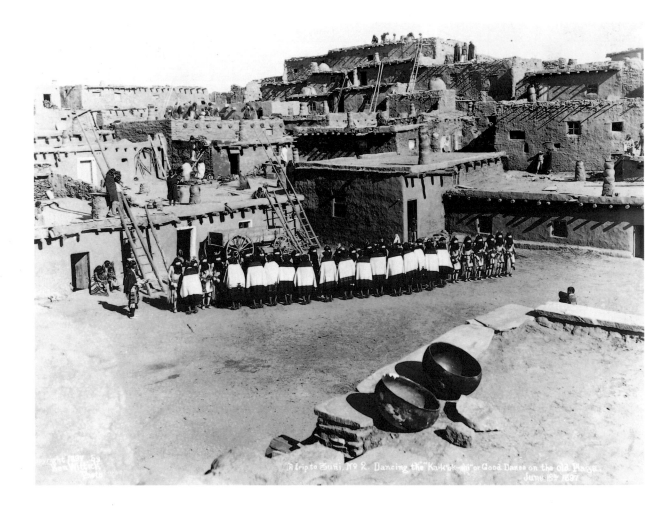

GEORGE BEN WITTICK, *A TRIP TO ZUNI, NO. 2. DANCING THE 'KA-KOK-SHI'
OR GOOD DANCE ON THE OLD PLAZA,* © 1897.

*George Ben Wittick photographed Southwestern scenes for at least two
decades at the end of the nineteenth century. In this depiction of the
"Good Dance" of the Zuni Pueblos, the ceremony appears private,
untouched by white people's restless curiosity.*

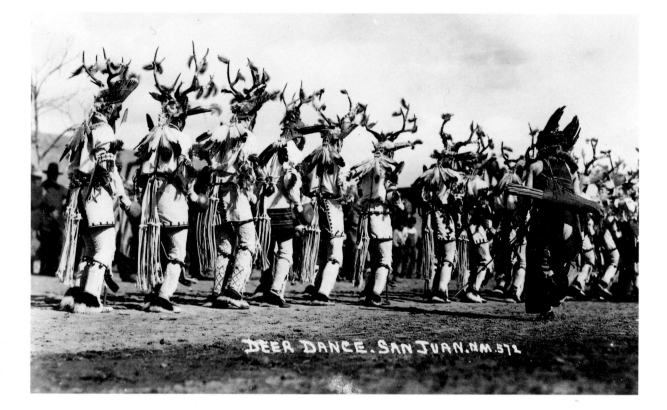

DEER DANCE. SAN JUAN. NM 572

Photographer unknown, *DEER DANCE*, date unknown.

As Native American ceremonies became tourist attractions, photographers turned to selling images of them on postcards. In this Pueblo dance near San Juan, New Mexico, participants dressed as deer parade behind a figure representing the eagle god. He in turn supplies the dancers with arrows for hunting deer, a gesture intended to bring good fortune to the town's hunters.

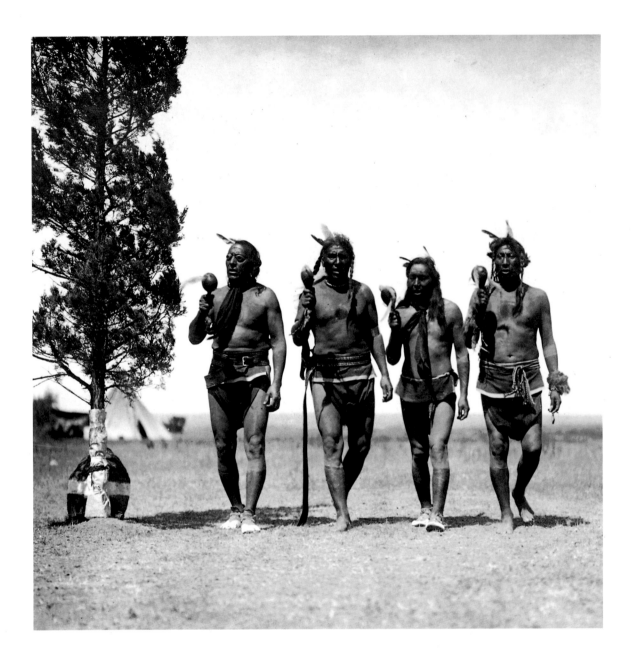

EDWARD S. CURTIS, *NIGHT MEN DANCING—ARIKARA,* © 1908.

The Night men or Mother Night men are members of the Medicine Fraternity, composed of nine groups who perform feats of magic within a large, sacred earthen lodge. The feats of the Mother Night medicine men include standing on red hot stones and leaping through fire. These individuals, who have probably concluded their night ceremony, carry medicine bundles in their hands.

AT HOME

In this section we turn from the sensational to the anthropological and also to other versions of the primitive picturesque. Photographer John C.H. Grabill turned the ghastly site of the Wounded Knee massacre into a vision of pastoral beauty just one year after the horrible event. In one of his masterfully composed versions of the pastoral, Edward Curtis toyed with the aesthetic effect of tipis reflected in a prairie pond. To photographer William J. Carpenter, a tipi on the northern Plains conjured up a sentimental vision of the rootlessness and loneliness of nomadic life.

Other "at home" photos were less sentimental and more anthropological, showing natives, mostly women, at work in varied environments beside dwellings that seem to grow out of their surroundings. The photographers saw clearly that, for native women, life "at home" was hard; in one instance, "warriors" watch while women tend to the bloody business of dressing out a dead buffalo. And camping out in nature, in the forests, or on the sub-arctic tundra could be a life of endless toil and privation, of a primitive quality that was not always so picturesque, merely squalid. The photographers of these camps revealed value judgments as powerful as Lewis Hine's vision of New York's urban slums.

Photographers encountering age-old permanent sacred structures such as the Hopi town of Walpi and a Hispanic and Native American church seemed as awed as they had been by tribal ceremonies. In contrast, Laura Gilpin's Pueblo man of 1939 displayed nonchalant contentment for the camera—a truce of sorts between white photographers' visions and Native American realities.

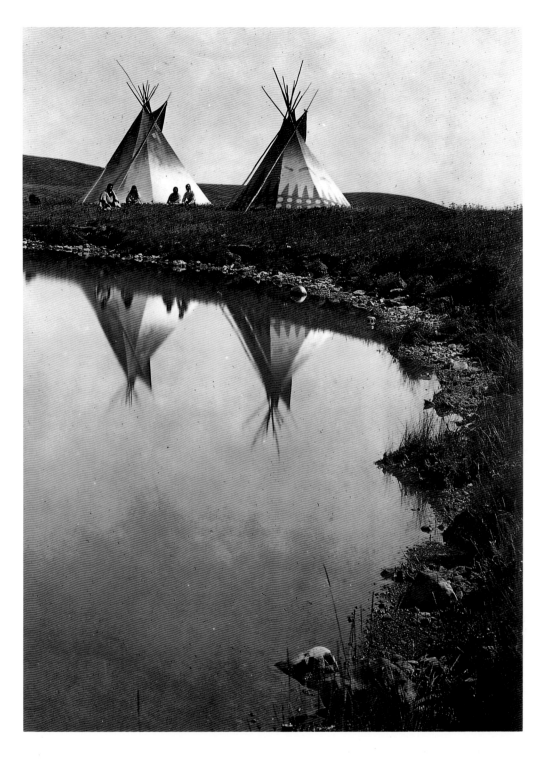

EDWARD S. CURTIS, *AT THE WATER'S EDGE—PIEGAN,* © 1910.

While Alfred Stieglitz and others were essaying art photography in the East, Edward Curtis was doing the same thing in the West. His view of two Piegan or Blackfeet tipis clearly has artistic pretensions. The tipis balance the picture and are duplicated in the pool, which is defined by a graceful, semi-circular curve.

41

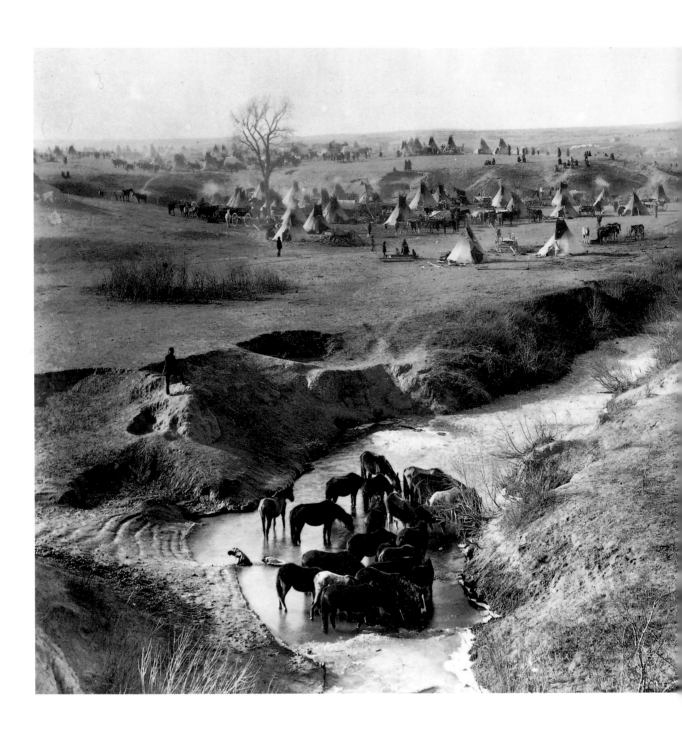

JOHN C.H. GRABILL, *VILLAGE OF BRULE, THE GREAT HOSTILE INDIAN CAMP ON RIVER BRULE NEAR PINE RIDGE, S.D.,* © 1891.

The village stands on the site of the Wounded Knee massacre of December 1890, in which the U.S. Army's 7th Cavalry destroyed Chief Bigfoot's band of Miniconjou Sioux, effectively concluding the government's decades-old war against Native Americans.

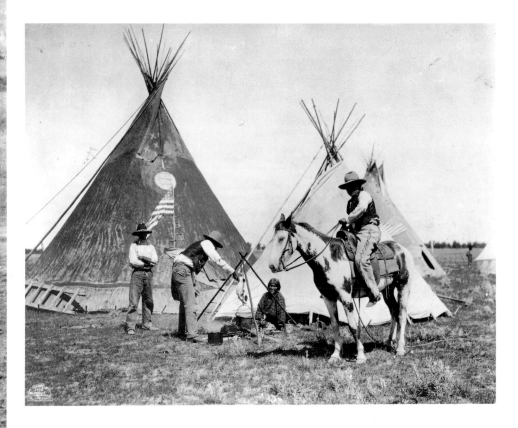

Photographer unknown, Detroit Publishing Company,
GROS VENTRE CAMP, FORT BELKNAP RESERVATION,
MONTANA, © 1906.

In this reservation scene, the Indian has become a cowboy.
There is no pretense of savagery. On the contrary, the
American flag in the background implies that the
civilizing process has begun, despite the Indian who is
dangling a small dog over the campfire. The Detroit
Publishing Company was founded in 1898 by western
photographer William Henry Jackson with film
processor William A. Livingston and assembled a huge
collection of western and worldwide photos around
a nucleus of Jackson's works. The company went
out of business in 1924.

43

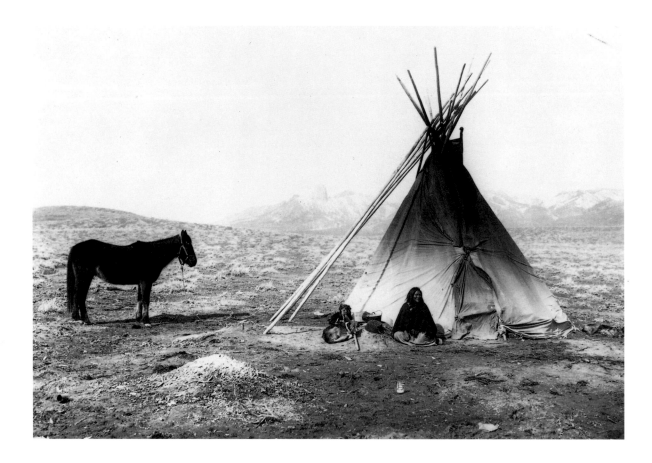

WILLIAM J. CARPENTER, *HOME SWEET HOME*, © 1915.

The mood of this scene, despite its seeming loneliness, is basically cheerful. The native woman has a smile on her face, and the dogs nestling against the sides of the tipi appear well-fed.

44

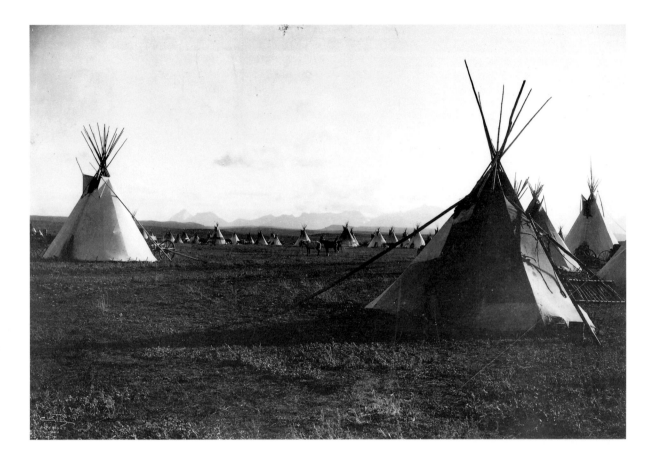

EDWARD S. CURTIS, *PIEGAN ENCAMPMENT,* © 1900.

In August 1899, Curtis accompanied Forest and Stream *editor George Bird Grinnell to the Blackfeet Reservation in Montana, where the Piegan were encamped, and thus began his thirty-year career as a photographer of Indians. As in* Village of Brule *(page 42) and* At the Water's Edge—Piegan *(page 41) the theme of the photo is peace, even among the once-fierce Blackfeet.*

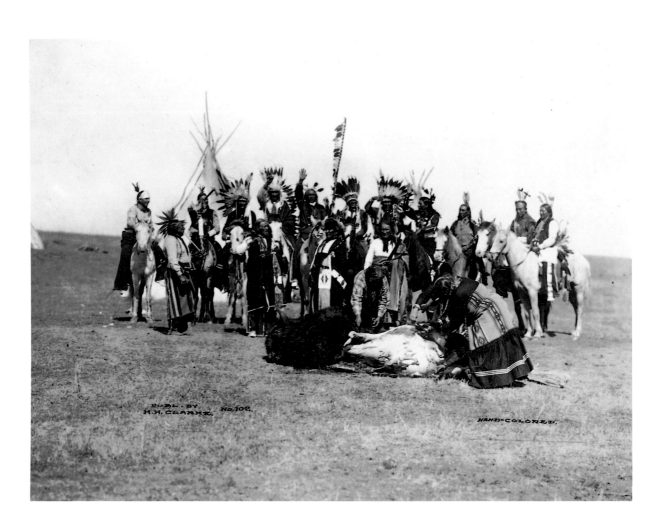

H.H. CLARKE COMPANY, *PONCA INDIANS SKINNING A BUFFALO,
101 RANCH, BLISS, OKLAHOMA,* date unknown.

*As this image suggests, Plains tribeswomen gutted and skinned
the buffalo killed by the men of the tribe. Normally, however, the
men did not put on their finest clothes to gather around and cheer
the women on. These Oklahoma Poncas were later taken to
California as part of the 101 Ranch Wild West Show when it
merged with the enterprises of movie impresario Thomas Ince
and became part of Inceville, his unique, integrated movie
company in the Santa Monica Mountains. There, instead of
skinning buffalo, they participated in the making of hundreds
of silent western films.*

46

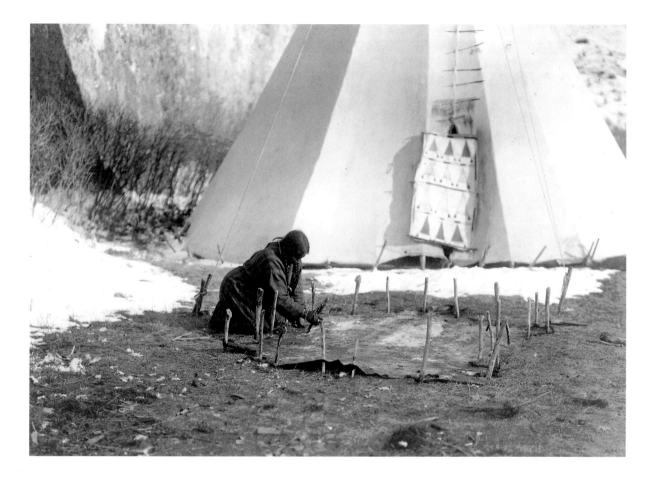

EDWARD S. CURTIS, *HIDE SCRAPING—ABSAROKA,* © 1908.

*Curtis' hide-scraping scene, like Clarke's, has been carefully staged,
but Curtis' view attempts to take us back to the archaic and to
indicate a process rather than present a cheap theatrical scene.*

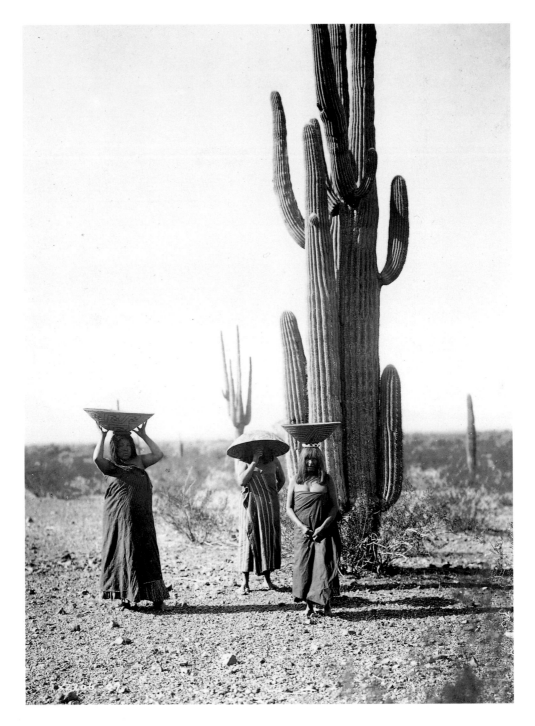

EDWARD S. CURTIS, *SAGUARO GATHERERS,* © 1907.

*These Maricopa women are gathering fruit from giant saguaro
cactuses. Like the neighboring Pima, whom Curtis photographed
in the same period, the Maricopa grew corn, squash, and beans
along rivers in central Arizona.*

48

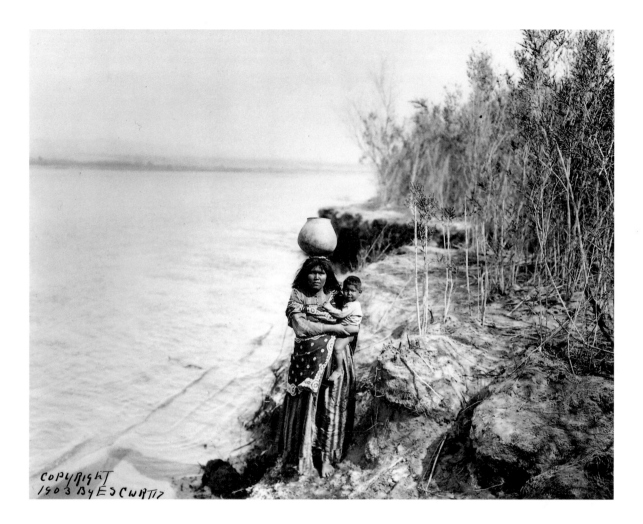

EDWARD S. CURTIS, *MOJAVE WATER CARRIER,* © 1903.

*Curtis' photographs of the Mojave Indians emphasize the extreme
simplicity of their life in the Southwestern deserts. Women who
carry burdens on their heads, leaving their hands free for children
and other responsibilities, have been a staple of ethnographical
photography from its earliest days.*

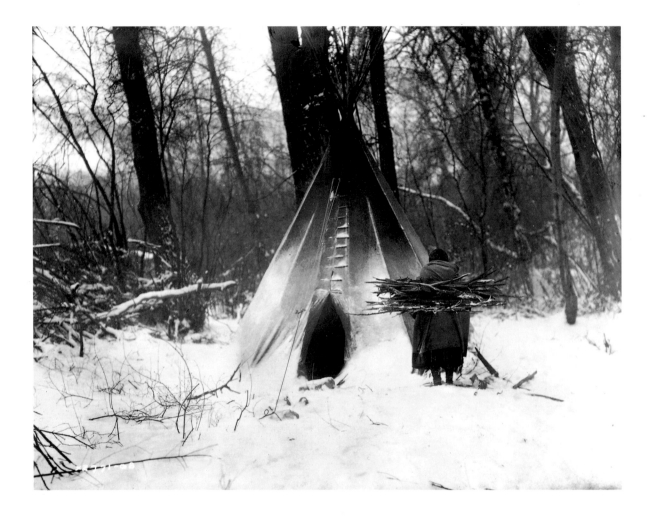

EDWARD S. CURTIS, *WINTER—ABSAROKA,* © 1908.

Here Curtis combines the graphic with the artistic, documenting the hardships endured by Native American women in the Montana-Wyoming wilderness while artistically contrasting the darkness of the woods and smoke-charred tipi with the whiteness of the snow in the bottom half of the picture, reversing traditional land and sky relationships.

50

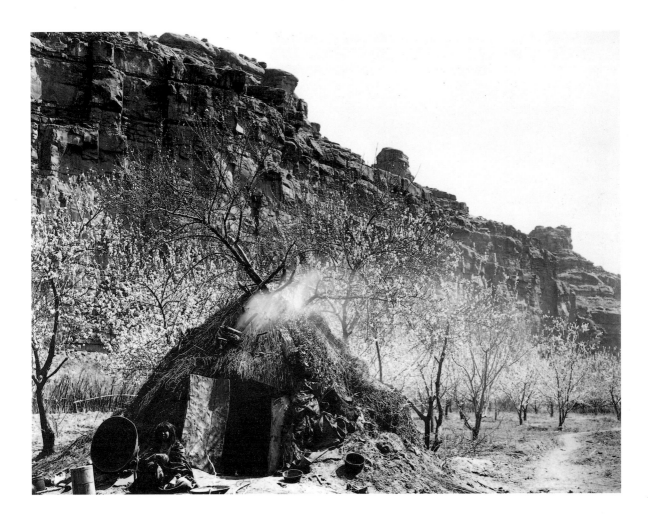

EDWARD S. CURTIS, *HOME OF THE HAVASUPAI,* © 1903.

The Havasupai, a tribe found in and near the Grand Canyon of Arizona, occupied a particularly harsh and barren region. They were first seen by mountain men such as Jedediah Smith on his expedition to California in 1826, then later by Mormon scouts. Studying the Havasupai, who had killed three of his men during his first daring voyage down the Colorado River, John Wesley Powell was inspired to urge the creation of the Bureau of American Ethnology.

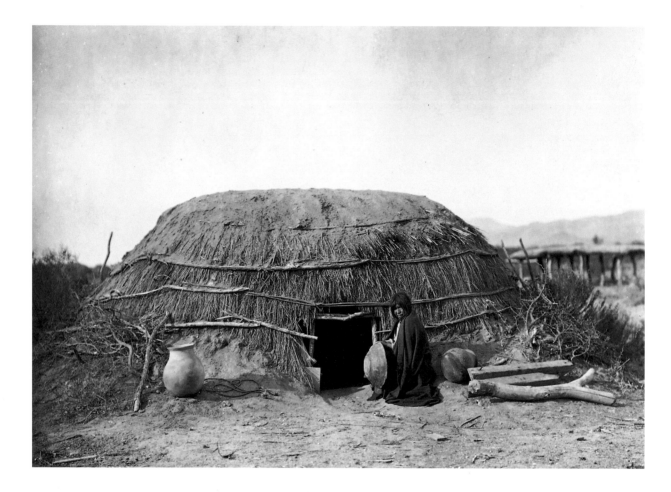

EDWARD S. CURTIS, *PIMA KI (PRIMITIVE HOME)*, © 1907.

The Pima, the most numerous tribe in the Southwest, lived in permanent villages along the Salt and Gila Rivers near present-day Phoenix. A sedentary people, their homes were more elaborate than those of the wandering Apache.

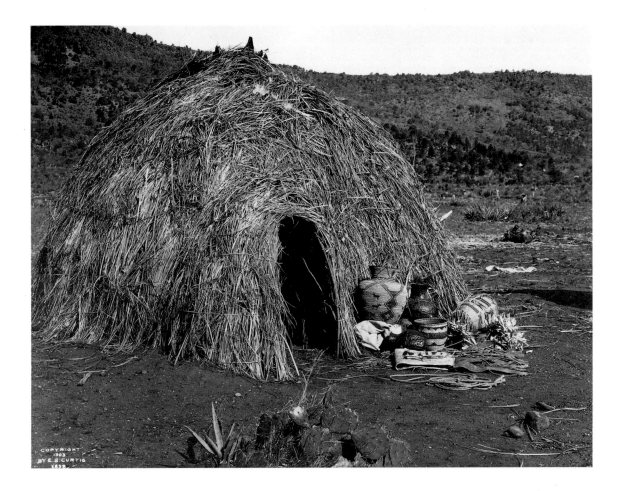

EDWARD S. CURTIS, *APACHE TIPI,* © 1903.

*The Apache were not truly a tribe, but a collection of highly mobile
nomadic bands. Consequently, their dwellings were brush huts,
hastily thrown together, not the grand Plains Indian tipis usually
associated with them in movies. Here Curtis also exhibits their
excellent basketry, which stands in contrast to their roughly made
homes. Curtis was always fascinated with native baskets and
pots and sold them in his Seattle studio along with other curios.*

53

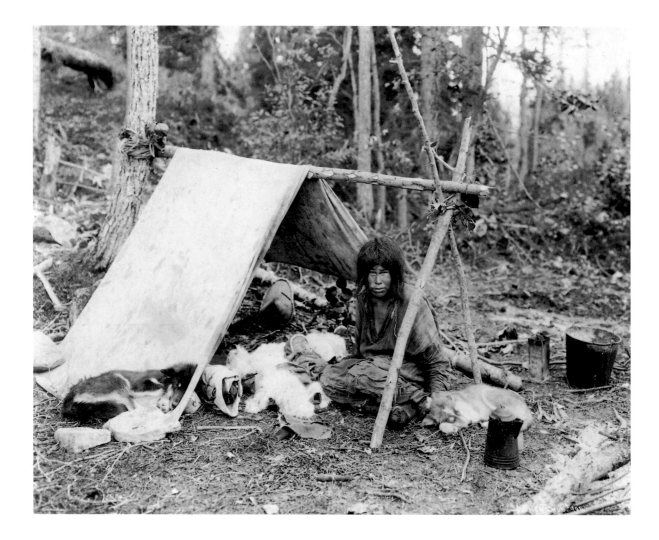

MILES BROTHERS, *ALASKA SIWASH MOTHERHOOD,* © 1903.

*The Miles Brothers were a photographic agency with offices in
New York and San Francisco. Unlike Curtis, who deeply respected
the simplicity of native life, the Mileses emphasized the misery and
squalor of the Siwash; another from the same file is sardonically
titled "Siwash Unwashed." And where Curtis often carefully
excluded non-native artifacts, this tableau clearly shows a factory-
made iron kettle and coffee pot.*

54

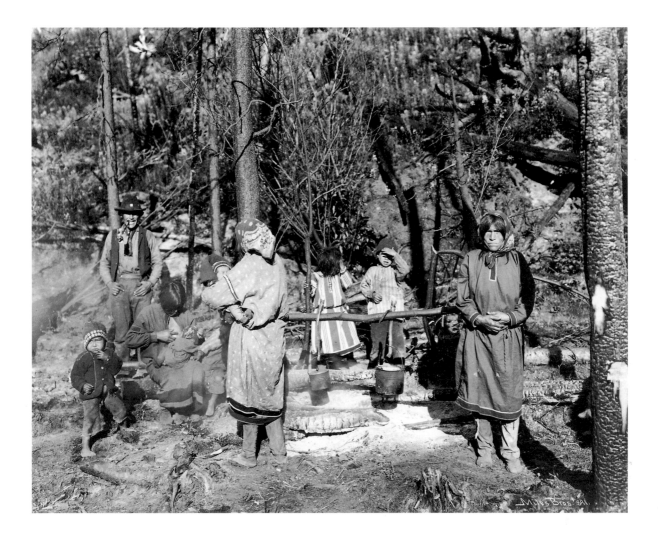

MILES BROTHERS, *SIWASH CAMP ON THE KOTSINA RIVER*, © 1903.

Most Alaskan photographers concentrated on Gold Rush pictures, but the Miles brothers were also intrigued by the natives. In contrast to the woman on the opposite page, these Siwash are well-dressed, partially in white man's clothing, which they may have obtained while working for copper prospectors or on a trip to Valdez for winter supplies—Siwash activities which the Mileses also documented.

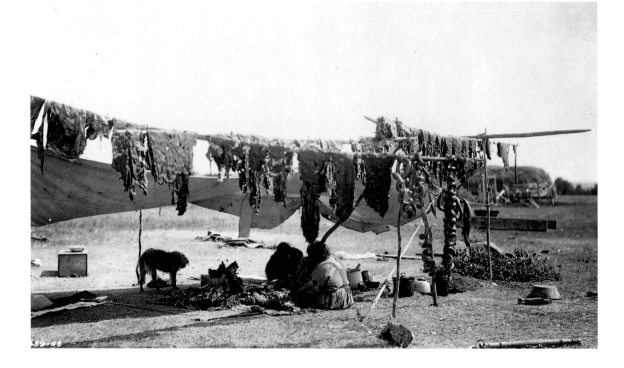

EDWARD S. CURTIS, *IN CAMP,* © 1908.

After finishing the first volume of The North American Indians, *which covered the Apache and the Navajo, Curtis turned to the Pima, Papago, and Mojave tribes of Arizona. Here meat is being dried on the racks above the campfire.*

56

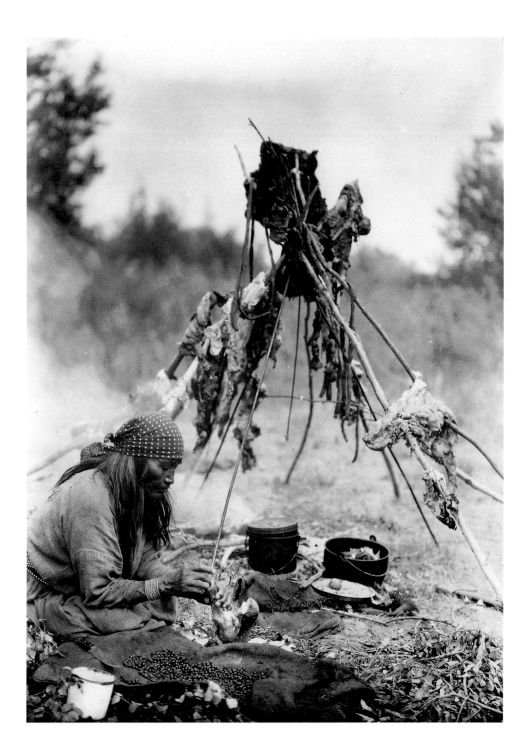

EDWARD S. CURTIS, *A SARSI KITCHEN,* © 1927.

The Sarsi, who traditionally lived east of the Rockies along the Saskatchewan and Peace Rivers, surrendered their lands to the Canadian government and moved to a reservation near Calgary, Alberta, after 1880.

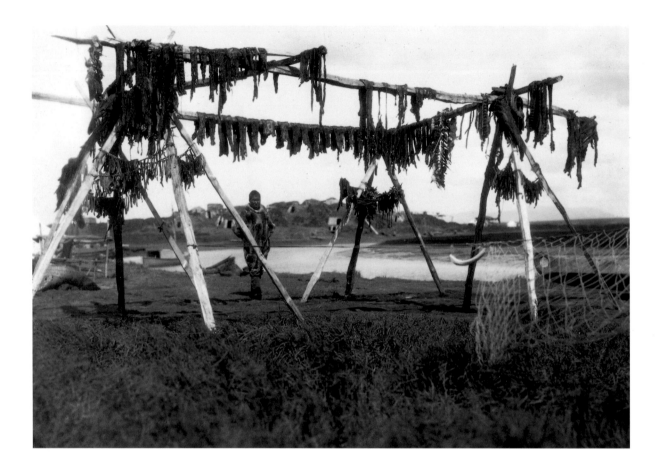

EDWARD S. CURTIS, *DRYING WHALE MEAT—HOOPER BAY*, © 1929.

In the summer of 1927, Curtis and his daughter Beth photographed the natives of Norton Sound, Hooper Bay, and Nunivak, Alaska. Here strips of walrus and whale meat are being smoked in great quantity. As in the photos on pages 56 and 57, Curtis seems more intent than usual on documenting the native way of life than on making art photos. Curtis' Alaskan trip carried him through the Bering Strait to the Kotzebue Sound and the Arctic Sea, where he met with furious stormy weather in which he almost perished.

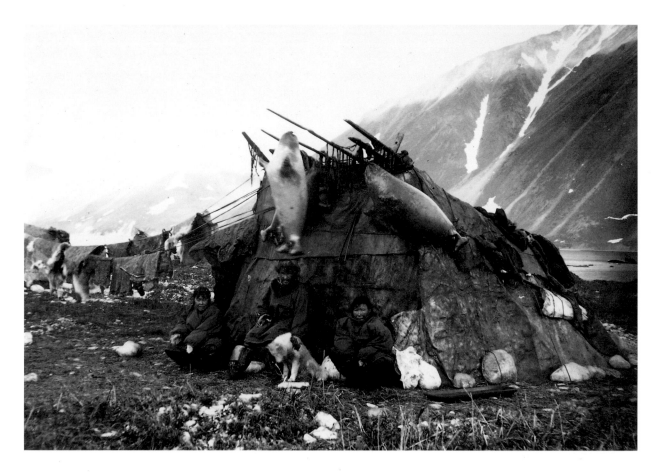

EDWARD S. CURTIS, *INUIT HUT AND FAMILY,* © 1899
(see signature on lower left).

Curtis' work as the photographer on the Harriman Expedition to Alaska in 1899 differed sharply in style from his later pictures for The North American Indians. *The prints were black and white, not his characteristic sepia, and they indicated little sentimentality and a quasi-scientific viewpoint. In this image, Curtis could not entirely suppress his artistic inclinations; the miserable sealskin tent in the foreground echoes the form and contrasts with the grandeur of the mountains behind it.*

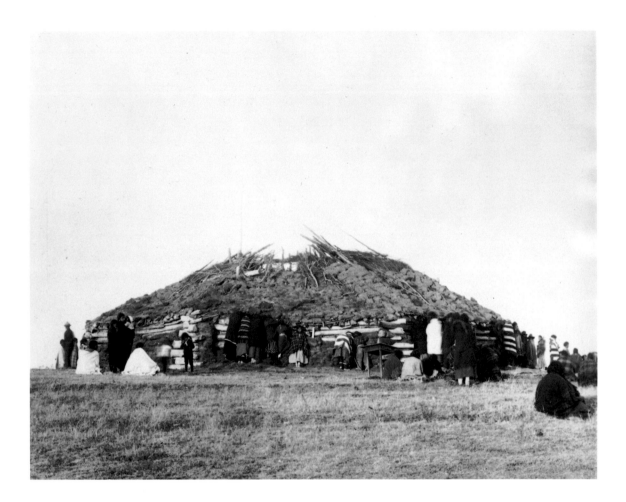

J.A. ANDERSON, *SIOUX INDIAN DANCE HOUSE,* © 1911.

The Sioux usually lived in tipis. This ceremonial structure, however, bears a striking resemblance to the log and sod houses of their traditional enemies, the Mandan, though it seems more hastily thrown together. As natives appear to be peering inside through chinks in the log walls, a ceremony may be in progress within—one to which the photographer has not been admitted.

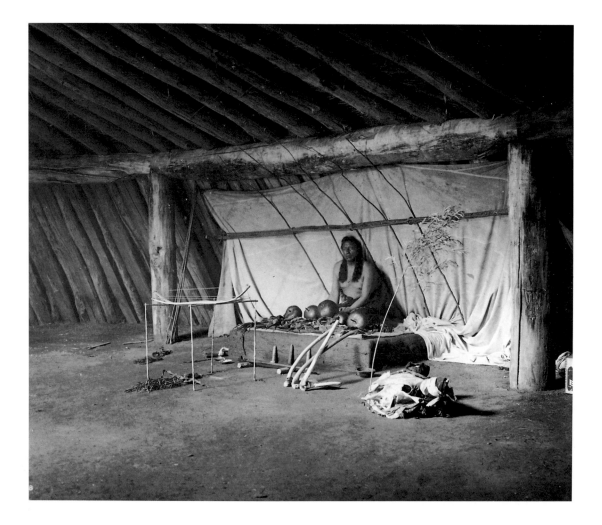

EDWARD S. CURTIS, *THE ALTAR—ARIKARA,* © 1908.

The Arikara lived downriver from the Sioux and Mandan along the Missouri in the prairies of present-day North Dakota. Trees were plentiful in their territory, and they built their dance houses of logs. Fierce and suspicious toward outsiders, the Arikara nonetheless liked Curtis enough to admit him to their holy sanctuary in which the medicine ceremonies took place. This view depicts the altar and principal medicine man.

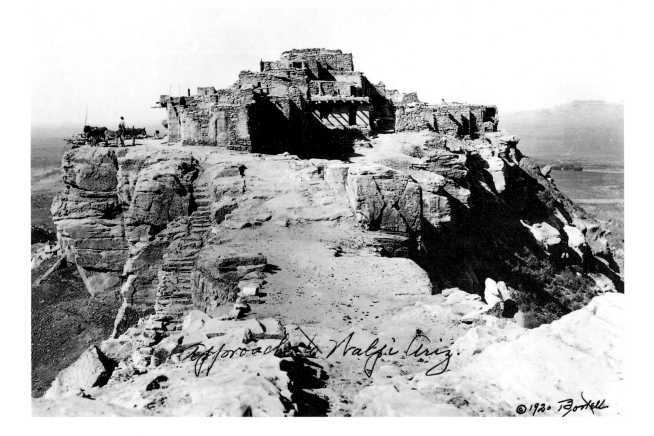

P. CLINTON BORTELL, *APPROACH TO WALPI, ARIZONA,* © 1920.

*Bortell's photograph shows a keen appreciation of the geometry of
this Hopi town on its sacred mesa. The perspective places Walpi
or Hualpi starkly against the sky, linking it to the great sky spirits,
while the bridgelike road in the foreground connects the village
and its people to the rest of humanity. Many other Southwestern
photographers from Adam Clark Vroman at the turn of the century to
Laura Gilpin in the 1930s made similarly dramatic shots of Walpi.*

62

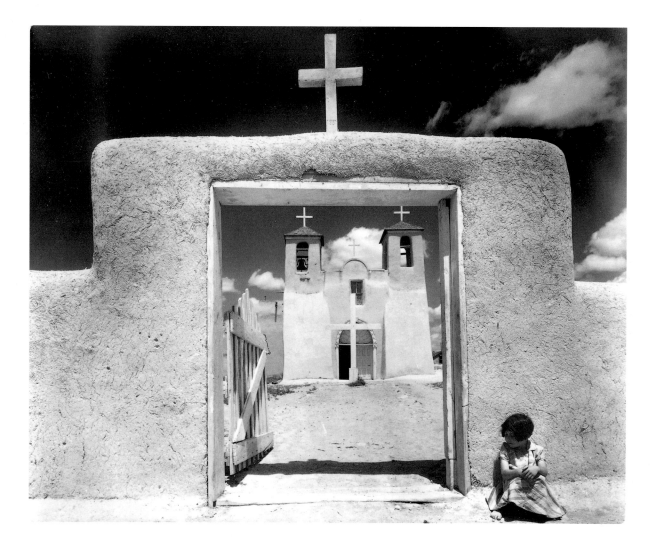

LAURA GILPIN, *LOS RANCHOS DE TAOS CHURCH*, © 1939.

Though the famous Hispanic edifice at Ranchos de Taos had been featured in thousands of tourist and art photos, Gilpin uniquely placed the church within the frame of its outer gate, thus making a picture within a frame within another picture and frame, the photograph.

63

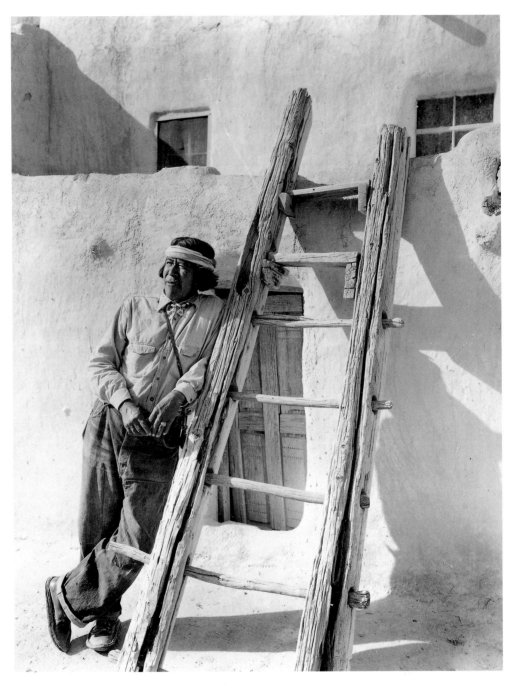

LAURA GILPIN, *ACOMA PUEBLO: THE LADDER,* © 1939.

*As if to break the solemnity of Pueblo pictures, Gilpin portrays
this native casually leaning against a ladder. Irony and perhaps
humor prevail, while there is no hint that Acoma itself is perched
precariously atop a high mesa west of Albuquerque. In earlier days,
photographs of Acoma always had about them a quality of mystery.
Acoma was also the scene of one of Spanish explorer Francisco
Coronado's most furious engagements with the Pueblo peoples.*

CRAFTS

The photographs in this section depict Native American "makers," craftspeople for the most part. Though images like Roland Reed's *Stringing the Bow* often have artistic values that echo past masterpieces, they also have an earthy, unintentional humor. We include them in part because they reveal the Native American's essential skill, as well as the qualities they share with preindustrial peoples all over the world.

Many of the objects being made by Native Americans at this time were taken up by the Crafts Movement and touted by aficionados and decorators such as the California developer George Wharton James in his many articles in *The Craftsman* magazine—a publication that also featured handmade "Mission" furniture and the productions of William Morris, who was protesting industrialization in England.

The photos here are only a small sample of the thousands of views of Indian arts and crafts, the source of a whole tourist aesthetic which proved to be the primary means of support for many of the natives of the Southwest, some of whom, like Maria, the potter of San Ildefonso, became famous. These Indian arts and crafts and tourist visits to the places of their makers were exploited by the railroads and the Harvey hotel and restaurant company, whose buildings, including the renowned El Tovar Hotel at the Grand Canyon and the La Fonda in Santa Fe, invariably imitated the Pueblo style.

Beyond arts and crafts, tourists were intrigued by the thousands of mysterious petroglyphs that covered the caves and canyon walls of the Southwest. For the anthropologist, they represented a career in deciphering. For the photographer, they evoked a mysterious Anasazi past, older by far than the culture of the current natives. Such petroglyphic mysteries, together with long-abandoned cliff palaces like those at Mesa Verde and Canyon de Chelly, made the Southwest irresistible to tourist and scholars alike. They created still another industry: the selling of amateur archaeological finds and the looting of pots.

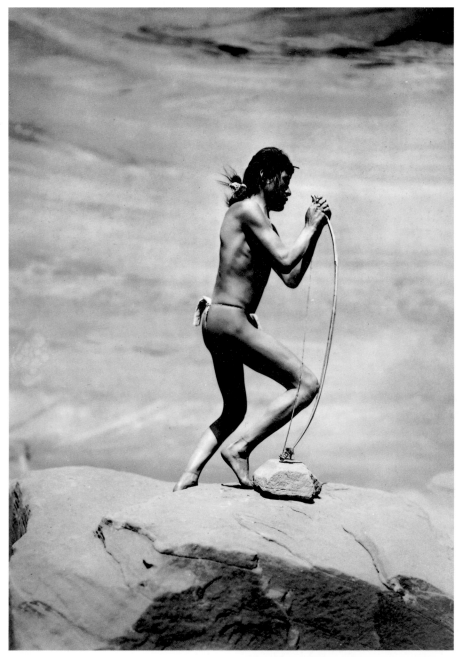

ROLAND REED, *STRINGING THE BOW*, © 1913.

*Roland Reed closed his Bemidji, Minnesota, studio in 1907 and set out to
rival Edward Curtis in photographing the natives of North America. He
employed a wet-plate camera "as large as an apple box," which meant
that he had to carefully pose his subjects. He soon realized that he could
not recreate preconquest natives in their costumes, so he tried, and
achieved success with, art photos.* Stringing the Bow *is one of several
stunning classical views he made of a young Navajo. One of the others
is sentimentally entitled* Broken Arrow.

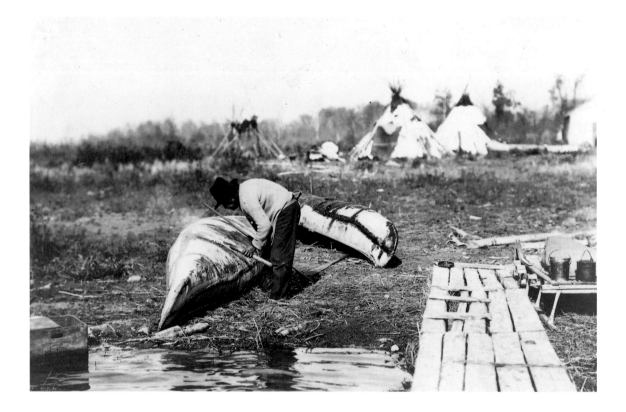

CARL GUSTAVE LINDE, *MENDING HIS CANOE,* © 1913.

This is probably taken in a Chippewa village, possibly at Lake of the Woods, Ontario, where Linde had his studio. The canoe is covered in birch bark; its seams are patched together with tree gum.

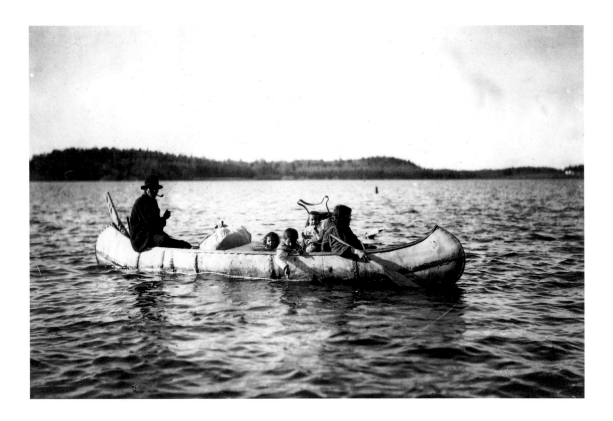

CARL GUSTAVE LINDE, *TYPICAL NATIVES,* © 1913.

With the canoe repaired, photographer Linde appears to have persuaded his native contact to bring out the family for a pleasure cruise. While the preceding photograph appears to document an authentic native skill, this image, which evokes a Sunday outing in the family carriage, seems to have been shaped more by the photographer's culture than his subject's.

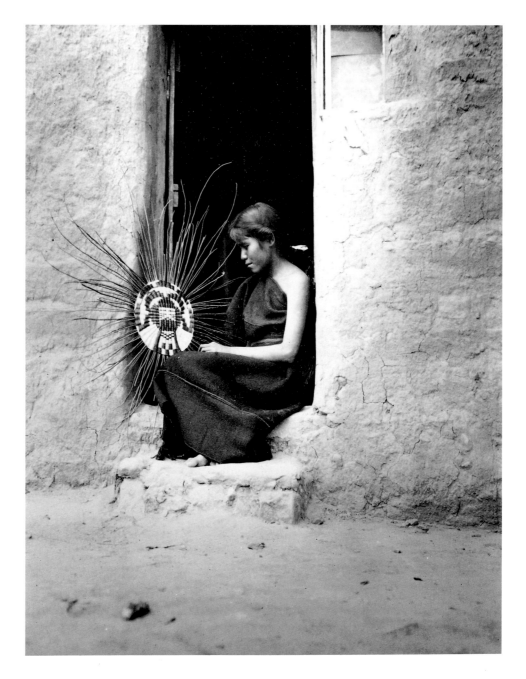

FREDERICK MONSEN, *HOPI BASKET WEAVER,* © 1909.

Monsen, a close friend of Adam Clark Vroman, described himself as "explorer, geographer, ethnographer, artist, adventurer, lecturer and photographer." Monsen made several trips to the pueblos with Vroman to take photos as aids to the lectures from which he made his living. His splendid photographs, catching the Native American in typical activities, influenced the early Taos painters. Monsen, who was also a friend of George Eastman, used a 5" x 7" Kodak, unlike most professionals at that time.

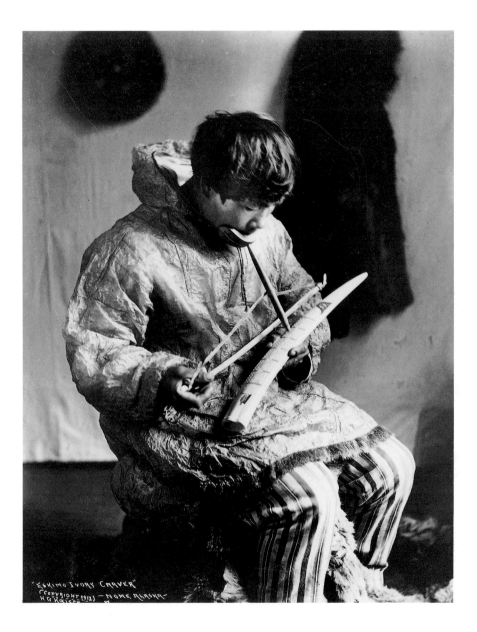

H.G. KAISER, *ESKIMO IVORY CARVER,* © 1912.

Kaiser was based in Nome, Alaska. His ivory carver is using a bow to cause his wooden drill to burn into and penetrate a walrus tusk.

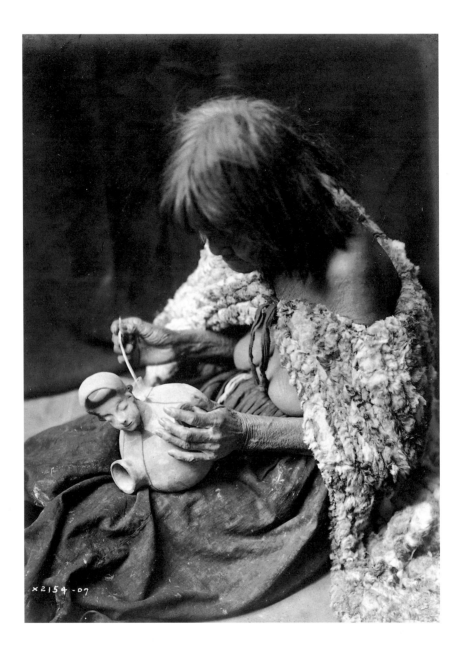

EDWARD S. CURTIS, *MOJAVE POTTER*, © 1907.

Note the contrast between the woman's primitive costume and the sophisticated water jug she is decorating, reminiscent of fine Meso-American work. It is clear that Curtis saw a link between the very primitive Mojave, who lived near the junction of the Gila and the Colorado Rivers, and Meso-American cultures that migrated north, such as the Arizona Hohokam, who left remains of Aztec-style ball courts.

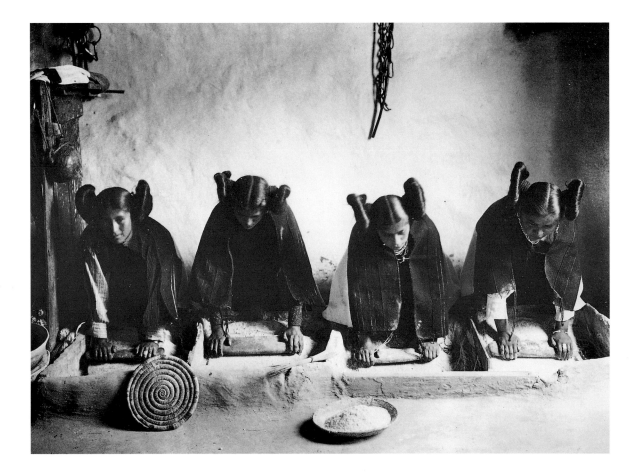

EDWARD S. CURTIS, *THE MEALING TROUGH—HOPI,* © 1906.

Their hairdressings indicate that these Hopi women are unmarried and on the lookout for husbands. At Hopi weddings, woven plates like the one made by the woman looking at the camera are tossed in great numbers to the guests.

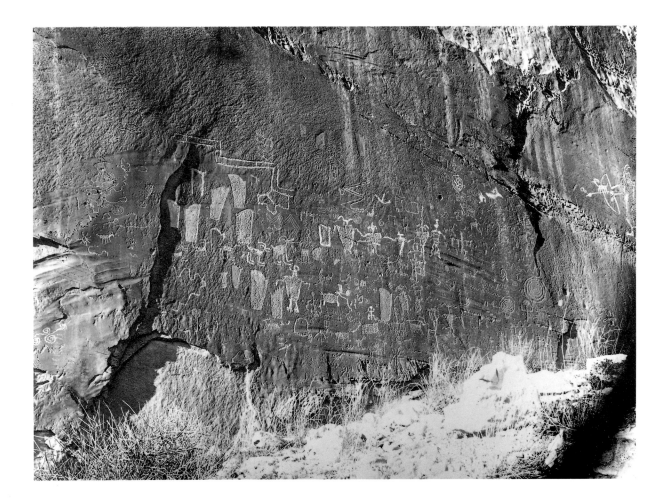

KOLB BROTHERS, *CLIFF DWELLING PICTOGRAPHS, GRAND CANYON,*
ARIZONA, © 1913.

This photo suggests the contrast between Anasazi visual communication
and Kodak photography as adopted by the native chiefs on page 28. The
Anasazi were an ancient culture, mysterious to natives as well as whites.
Chaco Canyon and Mesa Verde are two of their most famous dwelling
sites, and their pictographs can be found all over the Southwest. They
portray shaman figures, historical events, star patterns, and geographical
directions. In this picture, shaman or holy figures are clearly visible, but
so too, at upper left, are signs that could be descriptions of landscapes.

WARRIORS

C an't you still see those grand figures made popular by western movies, the godlike, fiercely painted, war-bonneted warriors who looked down from the heights at unsuspecting white men and women in distress? Edward Curtis, part of whose mind was always on the movies, could see them. So could dozens of other photographers, and "war party" pictures became one of America's most popular cliches. Because they were so popular and hence formative in both native and white American imaginations, we could not leave them out. The early silent movies thrived on these scenes because they were dramatic and needed no explanation. Moreover, moviemakers could build on or imitate the many views already made for a public weaned on dime novels and melodramas like Ned Buntline's 1872 *Scouts on the Prairie*, starring Buffalo Bill.

Gus Trager's Wounded Knee massacre pictures were not so romantic, but had almost equal appeal in a racist age. Trager, operating out of Chadron, Nebraska, was the first photographer to reach the Pine Ridge Reservation and the scene of the massacre in which 129 Native Americans—men, women, and children—were killed along with 39 troopers of the nervous 7th Cavalry. It was cold that last day of December 1890, and the frozen bodies lay all around in ghastly poses. So eager were people back East to see very dead savages, that Trager formed a special company to market his eleven grisly scenes of the last stand of the Native American, a premonition of the age of realism—or surrealism.

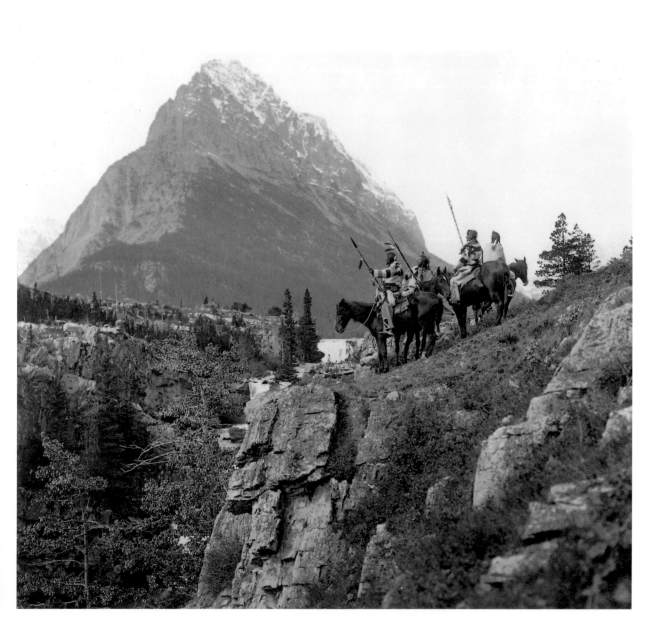

ROLAND W. REED, *THE LANDMARK*, © 1912.

Clearly inspired by early silent films, Reed poses natives, probably Blackfeet, in a salute to the mountainous grandeur of the northern Rockies. During this period, Reed was attempting to imitate Edward Curtis' photographic project with perhaps even more theatricality. His undertaking never came to completion.

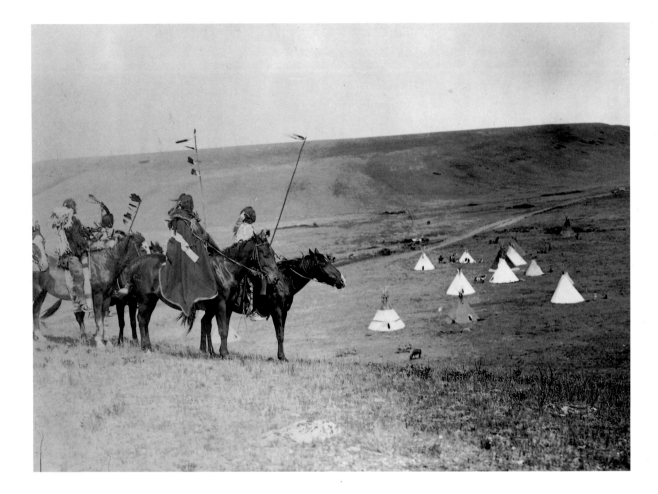

EDWARD S. CURTIS, *WAR PARTY'S FAREWELL—ATSINA,* © 1908.

*The Atsina or Gros Ventre, who had resettled in northern Montana
when Curtis photographed them, were allies of the once powerful
Blackfeet and the Plains Arapaho. They were mighty warriors,
and Curtis tries to portray them as such in this theatrical view.*

78

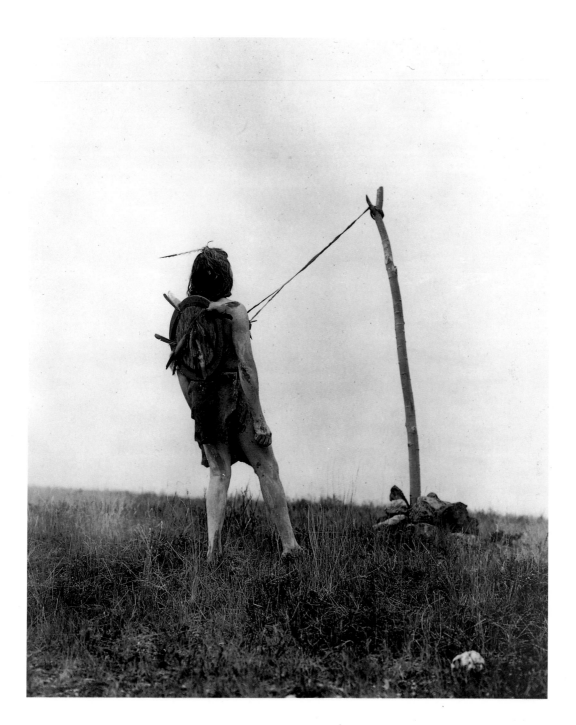

EDWARD S. CURTIS, *FOR STRENGTH AND VISIONS—ABSAROKA,* © 1908.

If the Absaroka warrior is indeed doing a one-man Sun Dance by passing sticks through slices in his pectoral muscles and then tugging on them to induce pain, Curtis' picture is a rare, astounding "photo opportunity." It looks as if the picture is posed, however, with the sticks passing only through the native's clothing, which is why his back is turned toward the camera. The pole, too, looks as if a stout tug might pull it down.

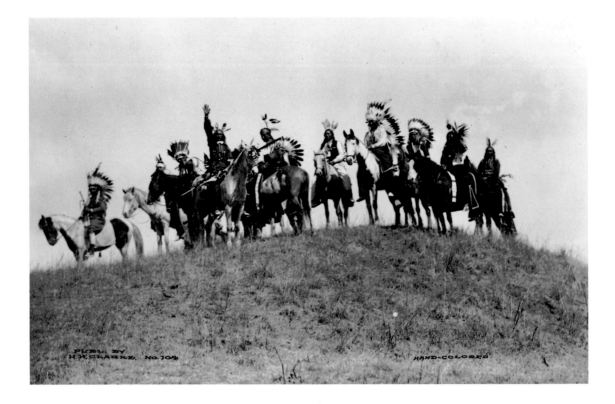

H.H. CLARKE, *PONCA INDIAN SCOUTS, 101 RANCH,*
BLISS, OKLAHOMA, © 1890.

This photograph may document a reservation pageant. The Ponca
had been allotted a reservation in their Nebraska homeland but
were driven out by hostile Sioux bands and forced to live in
Oklahoma. Their cause was taken up nationwide by Helen Hunt
Jackson, who lived for a time in Colorado Springs, where
photographer H.H. Clarke was also based. Clarke's photograph
may have been taken to aid Jackson's Ponca campaign.

80

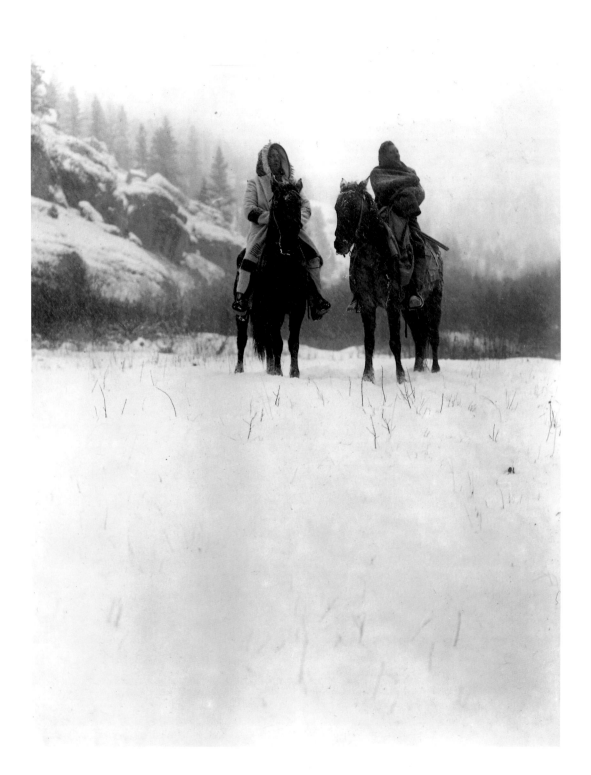

EDWARD S. CURTIS, *FOR A WINTER CAMPAIGN—ABSAROKA*, © 1908.

Several contemporary cowboy artists have copied this photograph, possibly because its winter setting creates a somber, elegiac mood and offers possibilities for setting off color.

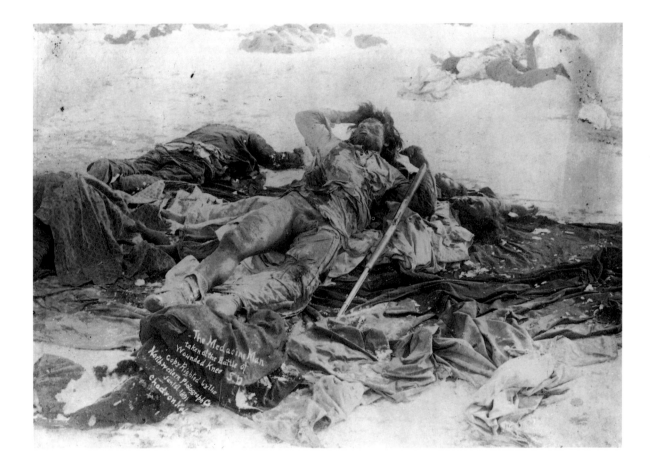

GEORGE TRAGER, *THE MEDICINE MAN TAKEN AT THE BATTLE OF WOUNDED KNEE, S.D.,* © 1891.

Among the most widely known of Indian photographs, this is one of eleven taken by George "Gus" Trager on December 31, 1890, the day after the massacre at Wounded Knee Creek, Nebraska. The dead man is the Miniconjou Sioux medicine man, Yellow Bird, who espoused hostile aspects of the Ghost Dance and may have encouraged the first Indian shots to be fired. Yellow Bird had assured his Miniconjou followers that special Ghost Dance shirts would repel bullets.

82

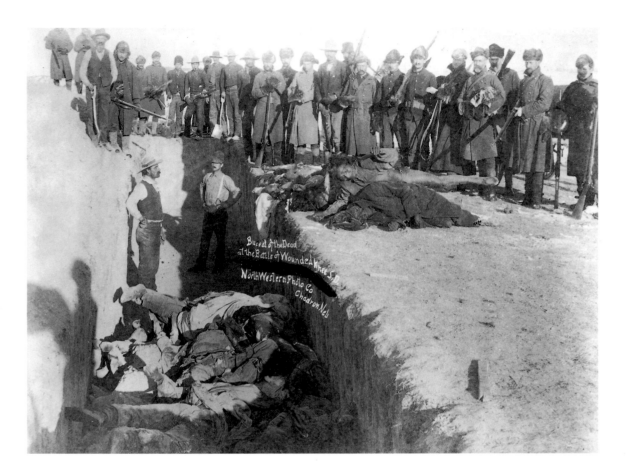

GEORGE TRAGER, *BURIAL OF THE DEAD AT THE BATTLE
OF WOUNDED KNEE, S.D.,* © 1891.

*Intending to capitalize on the only photographs of an Indian
battle, Trager specifically formed the Northwestern Photographic
Company to market them. The public, it appears, has always
viewed these scenes with horror, sometimes with outrage. They
take on an even more horrible significance in the company
of similar World War II concentration camp images
from Germany and Poland.*

83

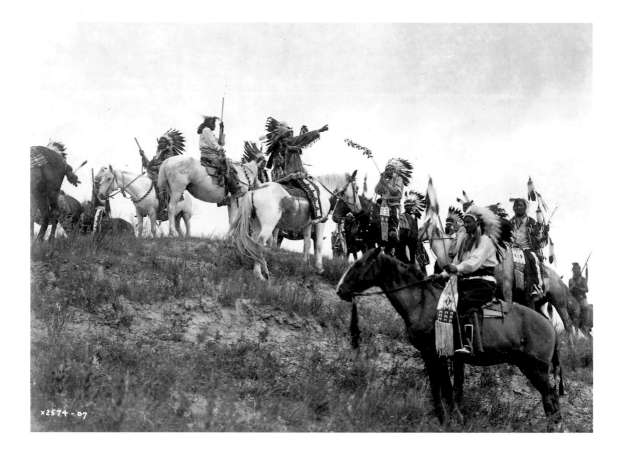

EDWARD S. CURTIS, *PLANNING A RAID*, © 1907.

In the summer of 1907, Edward Curtis held a feast for the Sioux Chief Red Hawk and three hundred tribesmen at Wounded Knee. The chief and his men then reenacted that battle as well as the Custer fight at the Little Big Horn. This scene, echoing triumph, probably reenacts the first sighting of Custer's forces.

84

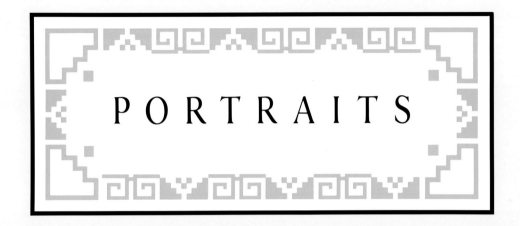

PORTRAITS

While Edward Curtis spent thirty years with a team of assistants photographing the activities of the Native Americans of the West and Alaska, he was, in many ways, most successful with his portraits. The portrait form, as American artists as different as eighteenth-century society portraitist John Singleton Copley and turn-of-the-century realist Thomas Eakins firmly believed, brings out the true characteristics, status, and emotions of the subject.

The Native American portrait photos we have selected also reflect certain distinctive realities and attitudes. Even though they are also "ceremonial" or posed pictures, they very often present the individual in all of his or her humanity: the splendid warrior, the proud family, the laughing bride, the solemn maiden, the skeptic. Photo historians have frequently remarked that few pictures of native sadness or anger were taken because the white photographer controlled the picture-taking circumstances. Our collection belies that generalization, and this does not just apply to photographs taken by Curtis.

In this section, portrait photographers from the East Coast to the Great Plains and from the Southwest to remote Alaska present us with a gallery of Native American expressions. In some cases, just as John Singleton Copley used props and dress to characterize his subjects, so too did photographers of the Indian resort to special effects, noted in the captions where possible.

One further note: because these portraits are so human and full of expression, we, as latter-day observers, have tried to place them in a sequence that very often allows one portrait to comment on another, as the portrait of Samuel American Horse (facing) is reflected by the child warrior chief on the following page. In a sense, this sequence of pictures, taken at widely differing times and places, might be considered an extended conversation between past and present, and the whole collection a chorus, or better still, a very moving last pow-wow.

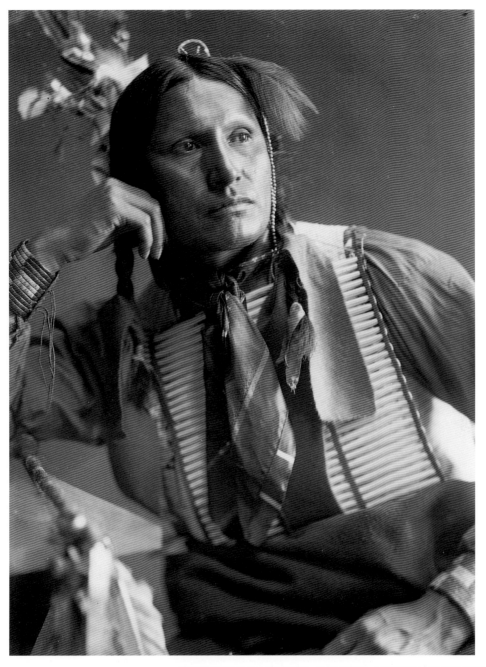

GERTRUDE KASEBIER, *SAMUEL AMERICAN HORSE,* © 1900.

Kasebier took Samuel American Horse's picture in 1900 when he appeared in Brooklyn, New York, with Buffalo Bill's Wild West Show. Kasebier was an artist who also had a New York portrait studio. In 1902, she became a member of Alfred Stieglitz's Photo-secession Club, which was formed to "promote studio photography as art." Kasebier portrays Samuel American Horse, son of the noted Sioux American Horse, as a proud, far-seeing warrior in full regalia. He is instantly immortalized in her widely viewed image.

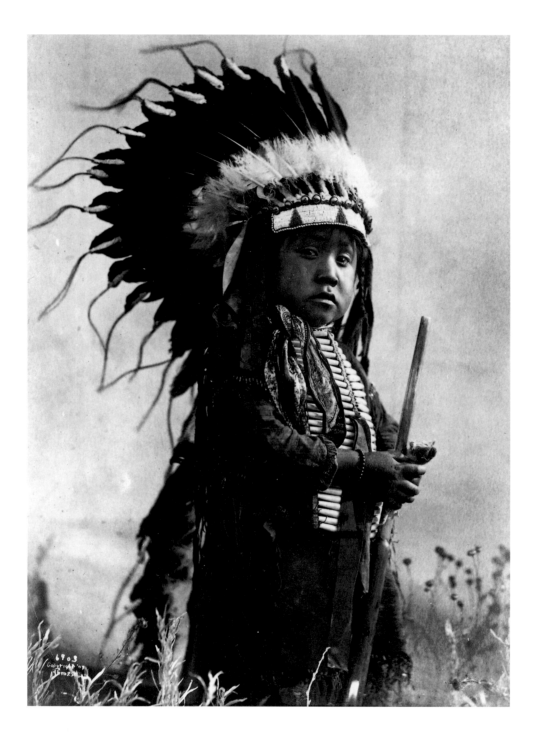

RICHARD THROSSEL, *A CHEYENNE WARRIOR OF THE FUTURE*, © 1907.

This portrait, taken by a photographer with no known links to Kasebier, nonetheless echoes her proud depiction of Samuel American Horse.

Copyright 1904
By E.S.Curtis
× 992

EDWARD S. CURTIS, *MANY GOAT'S SON,* © 1904.
Curtis perceives his Apache subject as a mysterious son of the
desert. Beginning with Lt. John Charles Fremont in 1845, visitors to
the southwestern deserts often compared nomadic natives to Arabs.
Curtis is also making a theatrical allusion to the exoticism of the
Middle East, which fascinated Americans and Europeans alike
while the Suez Canal was under construction and tourism
soared in that region.

89

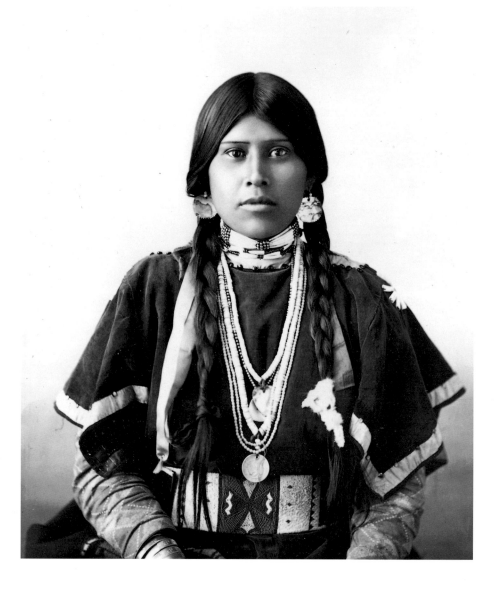

FRANK LAROCHE, *THE BELLE OF THE YAKIMAS,* © 1899.

LaRoche, a Seattle cameraman, is best known as the earliest photographer of the Yukon Gold Rush of 1897. He soon returned to Seattle and then worked out of Spokane. He made many landscape photographs, but his other specialty seems to have been Indian women. Another of his photographs is entitled "Belle of the Spokanes."

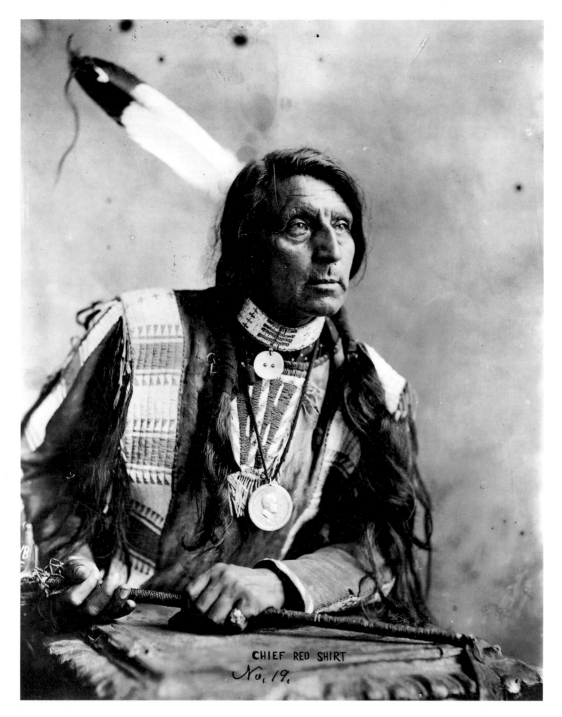

CHIEF RED SHIRT

No. 19.

HENRY W. WYMAN, *CHIEF RED SHIRT*, date unknown.

Red Shirt's peace medal was probably handed down from an ancestor who received it from the U.S. government. The costume decorations are glass trade beads made to resemble traditional porcupine quills, used for adornment by the Plains Indians from time immemorial. Wyman ran a curio store in Colorado Springs. The portrait was made at the St. Louis Fair of 1904.

91

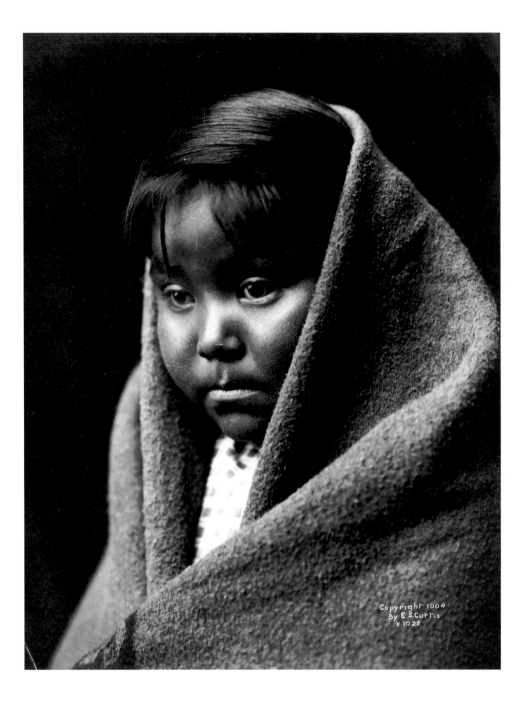

EDWARD S. CURTIS, *A CHILD OF THE DESERT,* © 1904.

The sadness of a vanishing race is reflected even in the eyes of this Apache child. Curtis took this photograph long after Generals George Crook and Nelson A. Miles had destroyed the militant western Apache bands led by such famous Native American chiefs as Cochise and Geronimo.

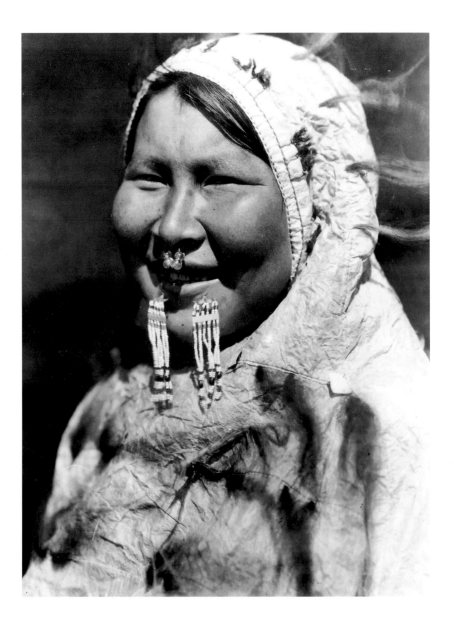

EDWARD S. CURTIS, *UGIYAKU—NUNIVAK,* © 1929.

This happy western Alaskan Eskimo maiden from a coastal tribe was considered beautiful because she was richly adorned with a nose ring and beaded lip labrets. It is possible that this photograph was taken by Curtis' daughter Beth, who accompanied him on the Nunivak Peninsula part of his 1929 Alaskan expedition.

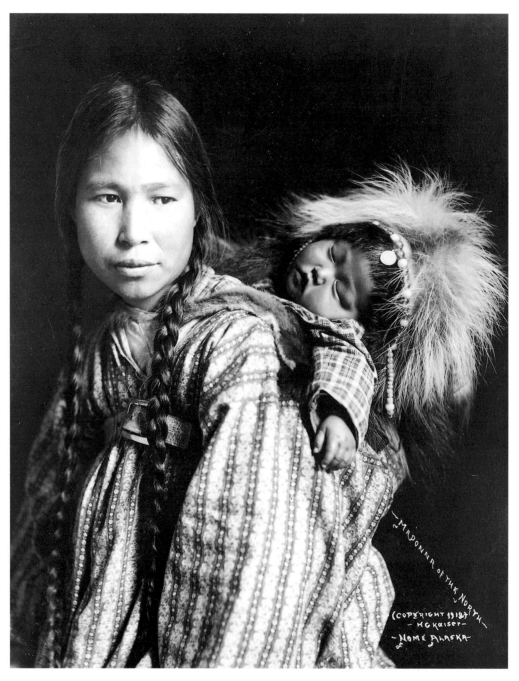

H.G. KAISER, *MADONNA OF THE NORTH*, © 1912.

Kaiser operated out of Nome, Alaska. By the time he took this picture, the demand for Gold Rush photos had died down, but interest in the natives was rising as anthropologists began to study the Bering Strait peoples. This picture, however, is a sentimental souvenir photograph probably made into a postcard for an increasing tide of tourists. Note the allusion to the Christian Madonna. Missionaries could not be far behind.

MILES BROTHERS, *TWO SIWASH BABIES,* © 1902.

*The Miles Brothers documented Siwash scenes while photographing
a possible railroad route for the Valdez, Copper River and Yukon
Railroad Co. These infants—one cries, the other doesn't—can also
be seen in the family picture on page 55.*

EDWARD S. CURTIS, *BIRD RATTLE,* © 1910.

In 1910, Edward Curtis divided his time in the field between eastern Washington and Vancouver Island. Bird Rattle is probably a Spokane tribesman. Clearly, Curtis saw him as a powerful, strong-featured, athletic man; he also brings to mind the famous Native American football player, Jim Thorpe.

BENJAMIN A. GIFFORT, *POP-KIO-WINA (SHORT ARM),* © 1899.

This sad-eyed native was probably a Columbia River Klickitat. Benjamin A. Gifford was known as the pioneer photographer of Oregon. He moved his studio from Portland to The Dalles, a town on the falls of the Columbia River, in 1892 because he was fascinated by the scenery and peoples of the area. Gifford considered himself a "documentary" photographer, but here he has created an artistically composed view of sadness. Gifford also took regional booster pictures for the Oregon Railroad and Navigation Company.

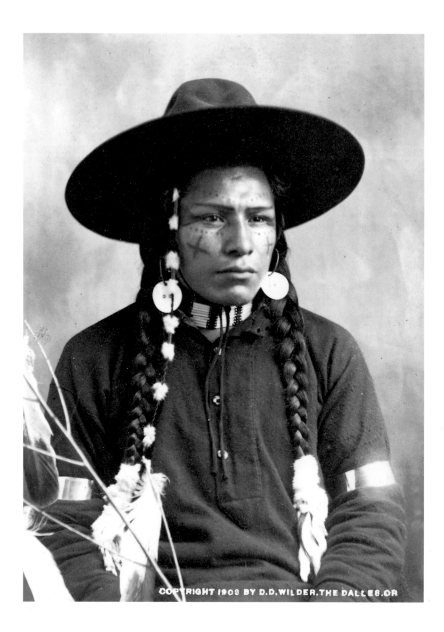

COPYRIGHT 1908 BY D.D. WILDER. THE DALLES. OR

DIO D. WILDER, *NUMBER FIVE*, © 1908.

Dio D. Wilder, apparently one of several photographers at The Dalles, had a store that sold "Photographs, Novelties and Indian Curios," appealing largely to tourists. The young man in the photograph seems a combination Indian and cowboy, which was not unusual, since thousands of horses ranged over the Columbia Plain.

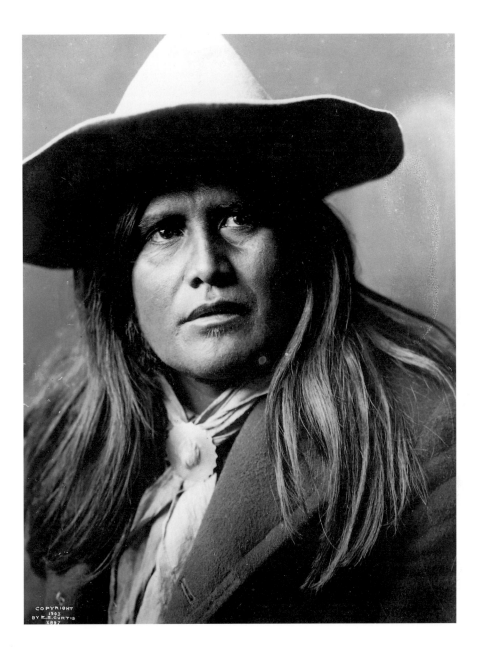

EDWARD S. CURTIS, *AN OSTOHO COW BOY—APACHE*, © 1903.

Here Curtis clearly seeks to make an art photograph, full of emotion and angst which recall "the melancholy Dane," Hamlet. Curtis often tried to give a special allusive character to his portraits, and when he took this one, early in his field career, he had yet to lose the visual habits of studio photography.

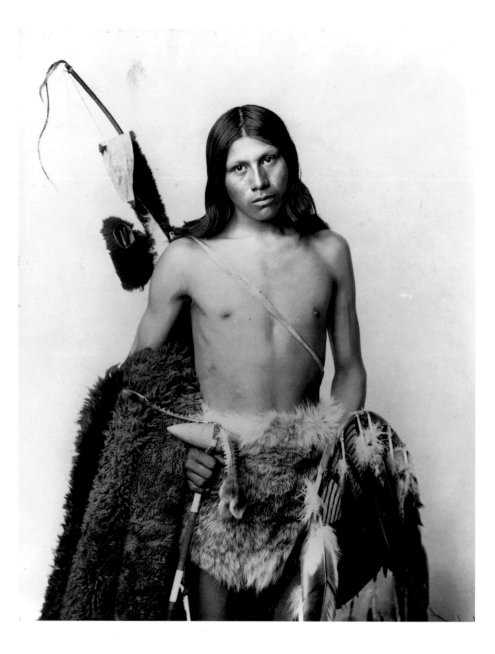

HEYN AND MATZEN, *WILLIAM FROG,* © 1900.

One of three portraits of William Frog copyrighted by Heyn and Matzen at the Library of Congress, this photograph was probably taken at the Indian Congress of the 1898 Trans-Mississippi and International Exposition in Omaha, where the Heyn and Matzen Studio was located. The photographer was undoubtedly Herman Heyn, one of six Heyns from Germany who were Omaha's most active photographers. The Exposition brought together representatives from all the western Native American tribes, some of whom performed dances and sham battles for tourists.

100

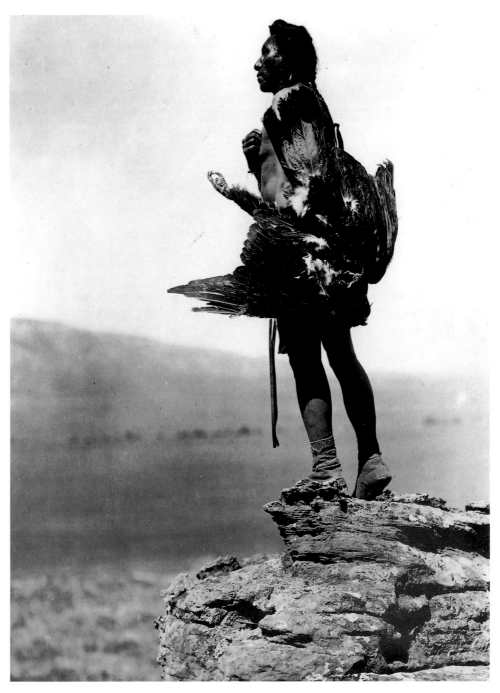

EDWARD S. CURTIS, *THE EAGLE CATCHER,* © 1908.

*Since Curtis spent the summer of 1908 with Red Hawk and the
Sioux near Pine Ridge in western Nebraska, his eagle catcher
must have been a Sioux. This character's pose is statuesque, not
documentary. Usually eagles were caught in a baited pit with nets
cast over them. Apparently they did not make good eating, but
their feathers had special ceremonial significance.*

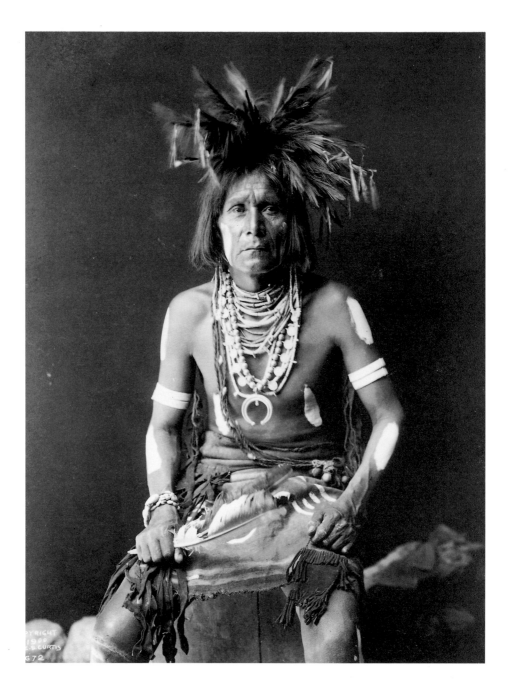

EDWARD S. CURTIS, *SNAKE PRIEST,* © 1900.

*Curtis' portrait of a Snake priest testifies to his first experience
with that awesome ceremony. In 1912 he returned to Hopi Mesa to
take part in the dance himself as an adopted Snake priest. He
wrote, "Dressed in a g-string and Snake Dance costume and with
the regulation snake in my mouth, I went through [the ceremony]....
Thankfully...the welcome rain began to fall."*
102

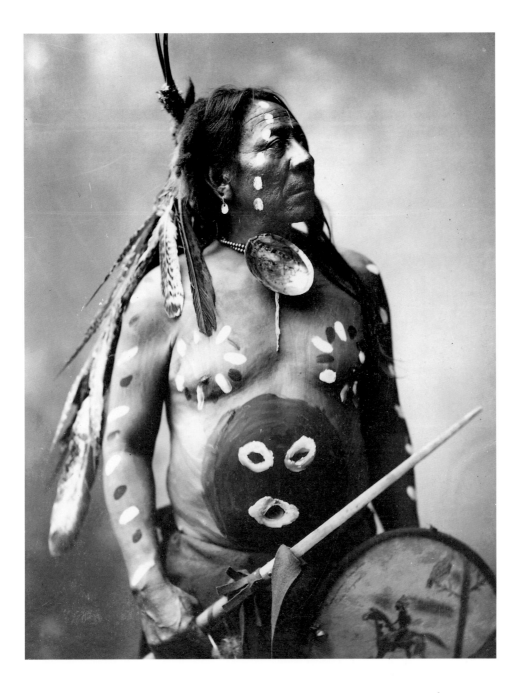

HERMAN HEYN, *LAST HORSE—SIOUX,* © 1899.
*This wonderfully painted Sioux posed for his portrait at the
Indian Congress of the 1898 Trans-Mississippi and International
Exposition in Omaha. Armed with spear and war shield, he
probably took part in the sham battles for tourists. Heyn and
Matzen must have sold numerous postcard copies of this picture
to the thousands of white visitors who had come to Omaha,
ironically enough, to celebrate the conquest of the West.*

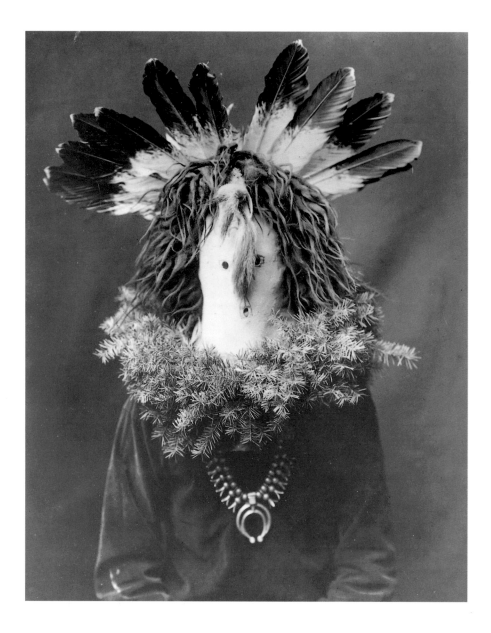

EDWARD S. CURTIS, *HASCHOGAN—NAVAJO,* © 1905.

*Given his strange mask and hair, this Navajo spirit figure resembles
a Hopi kachina or costumed clan spirit. The impression this
figure gives is more clownish than fearsome. Clowns were often
an important part of Southwestern native dances.*

104

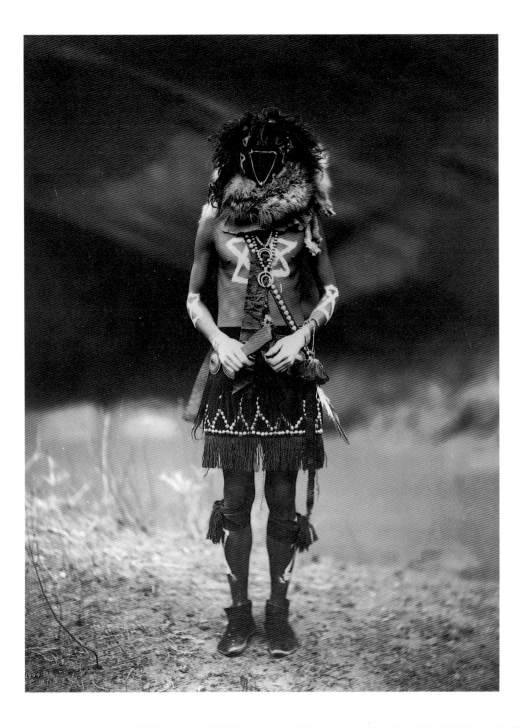

EDWARD S. CURTIS, *TOBADZISCHINI—NAVAJO MEDICINE MAN,* © 1904.

Posing his subject against a dark background, Curtis attempts to capture the mystery of the man who represents a spirit. Though only the Hopi had real kachinas, their neighbors and enemies seem to have partially imitated them. Tobadzischini's lavish, owl-like costume includes medicine pouches and charms.

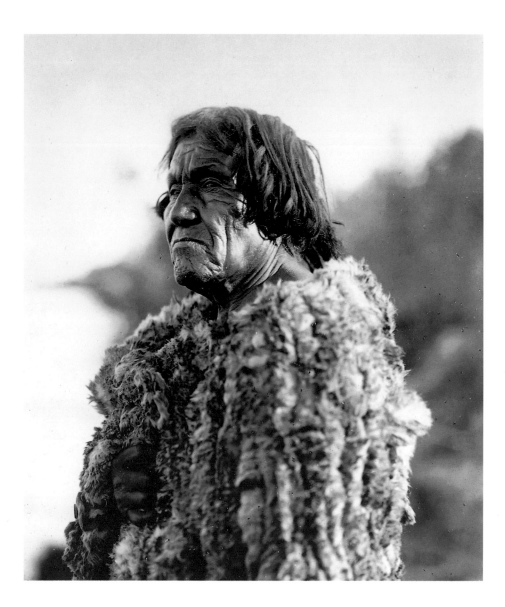

EDWARD S. CURTIS, *PRIMITIVE MOJAVE*, © 1907.

*To Victorians, the Mojave seemed to represent a far earlier point
in the evolution of culture than other Southwest desert peoples.
Emphasizing his subject's massive, fur-cloaked shoulder and
heavy jawline, Curtis powerfully conveys the pathos of a Stone
Age man confronting the twentieth century.*

106

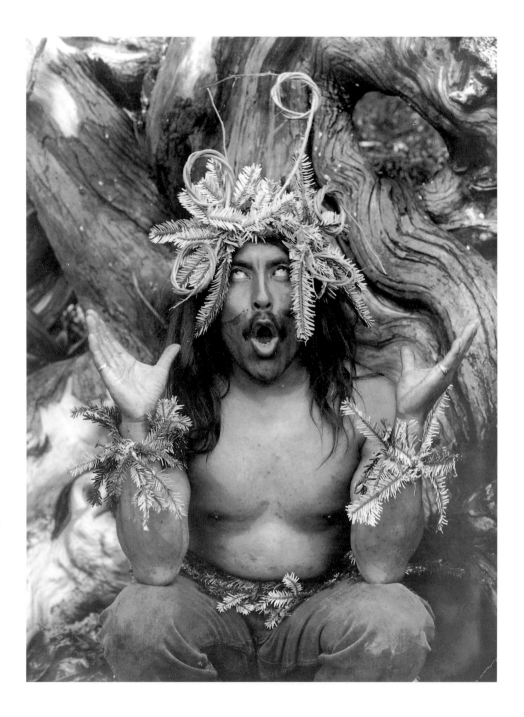

EDWARD S. CURTIS, *HAMATSA EMERGING FROM THE WOODS—KOSKIMO,* © 1914.

Among the Koskimo clan of the Kwakiutl, the Hamatsa was a "cannibal dancer." After being swallowed by the cannibal spirit Bakhbakwalanookswey, he was regurgitated and transformed into a cannibal himself. Curtis used the Hamatsa as a type of ghost in his movie In the Land of the Headhunters.

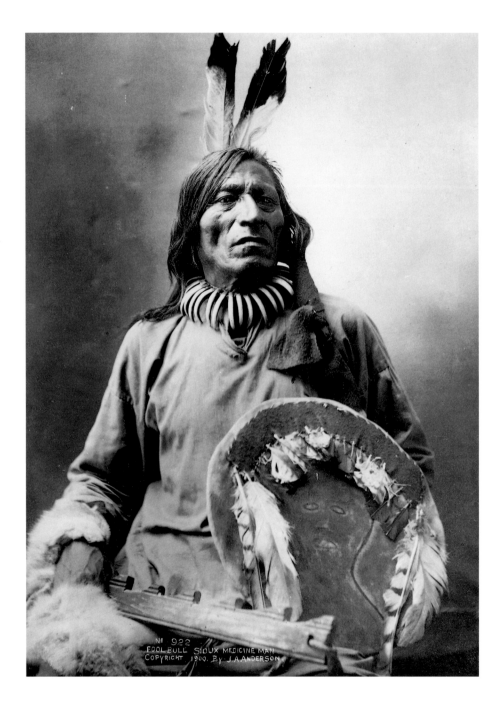

J.A. ANDERSON, *FOOLBULL, SIOUX MEDICINE MAN,* © 1900.

*The extravagant bear claw necklace and warriorlike pose with
bow, arrows, shield, and eagle feathers suggest that Anderson has
misinterpreted Foolbull's role. Sioux medicine men are not members
of the warrior clan. Sitting Bull, for example, did not fight at the
Little Big Horn; he stayed in the village.*

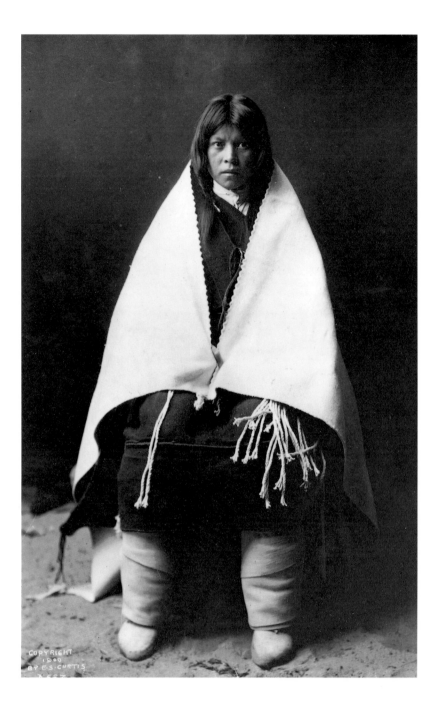

EDWARD S. CURTIS, *HOPI BRIDAL COSTUME* © 1900.

In preparation for the marriage ceremony, Curtis' subject has let down her hair from the vertical rolls that denoted virgin status among the Hopi (see page 73). Making this portrait of a Native American woman formally entering adulthood, Curtis brought to bear not only his enthusiasm for Hopi culture, but his expertise as a photographer of Seattle society weddings.

109

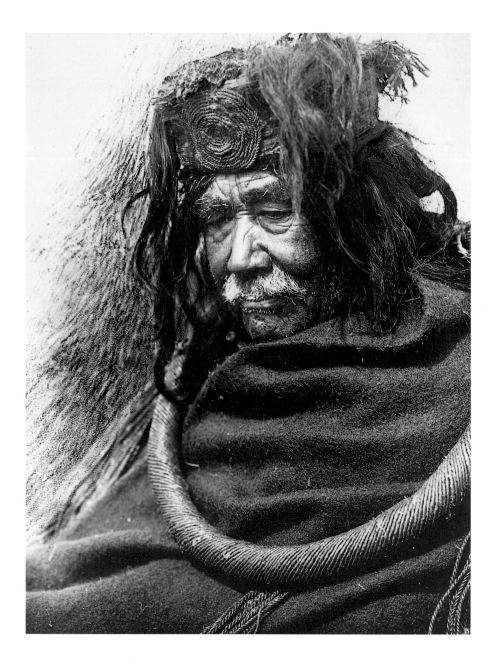

EDWARD S. CURTIS, *THE HAMATSA—NAKOAKTOK,* © 1910.

*Like the Koskimo Hamatsa (page 107), the Nakoaktok Hamatsa is
a Kwakiutl cannibal ghost figure. Curtis has underscored both his
sitter's age and melancholy and the oriental cast of his features.*
110

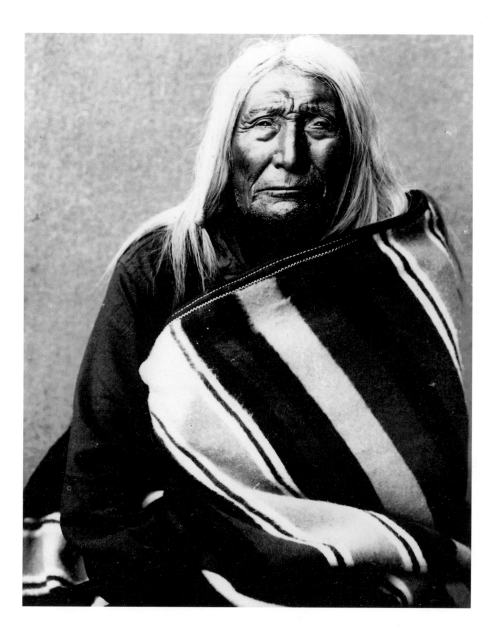

LEANDER MOORHOUSE, *HOO-SIS-MOX-MOX*, © 1900.

*Major Lee Moorhouse was an amateur photographer based in
Pendleton, Oregon. As the Indian Agent for Umatilla County, his
interest naturally turned to photographing the natives. At his
death in 1926, he left 10,000 glass-plate negatives documenting the
region. Here Moorhouse was probably recording an important
Umatilla chief for posterity. The portrait is artistically conceived;
the dramatic blanket contrasts with the native's solemn,
lined face and white hair.*

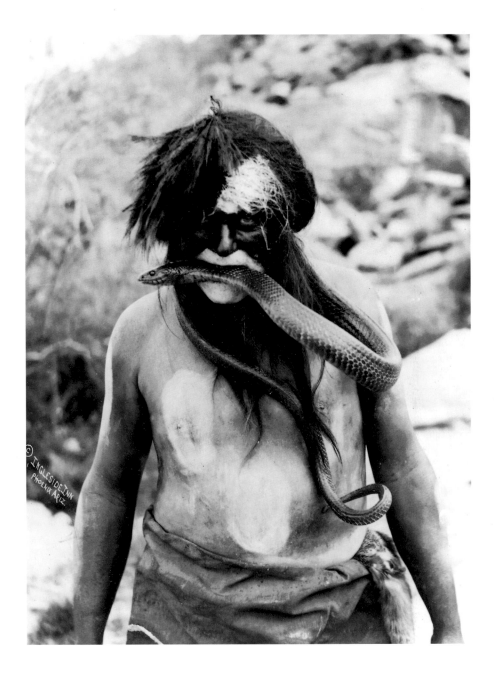

Photographer unknown, *HOPI INDIAN STUDY #28,* © 1924.

The Ingleside Inn, where this photograph was taken, stood in Phoenix, Arizona. Although the inn was intended to recall English country lodgings, its managers strove for local color with demonstrations by Native American snake dancers. The tourists were in no danger, however; the snakes were not poisonous.

112

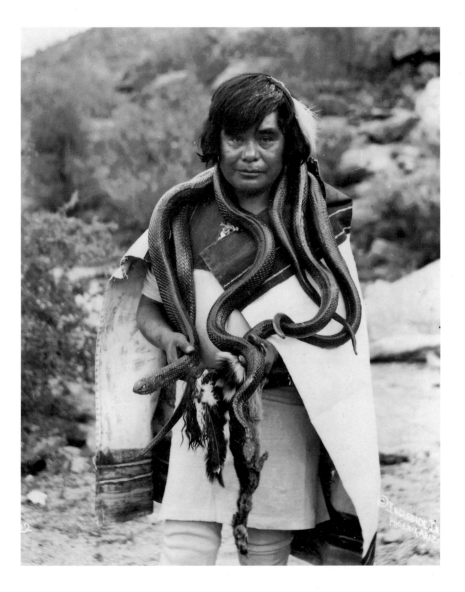

Photographer unknown, *HOPI INDIAN STUDY #22*, © 1924.

Also posing for the Ingleside Inn, this Hopi seems quite at home with his decolletage of massive, nonpoisonous bull snakes. Led by the Fred Harvey Company, which catered to passengers of the Santa Fe Railroad, the tourist hotels of the Southwest typically encouraged Native Americans to demonstrate crafts and customs on the premises.

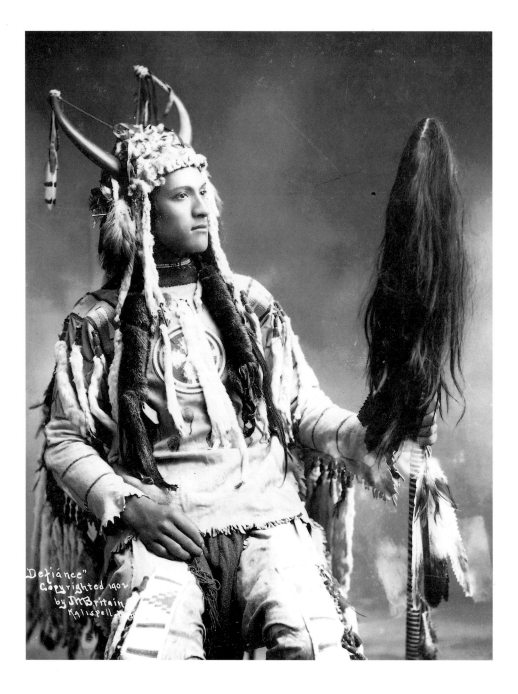

J.H. BRITAIN, *DEFIANCE,* © 1902.

*J.H. Britain worked in Kalispell, Montana. Britain's sentimental title,
combined with his subject's forced pose—his distant gaze, regal
posture, and highly visible scalp trophy—suggest how eagerly even
the most obscure frontier photographers romanticized Native Ameri-
cans once their cultures no longer threatened frontier life. This man,
photographed repeatedly by Britain, was named Kaukenaukot.*

114

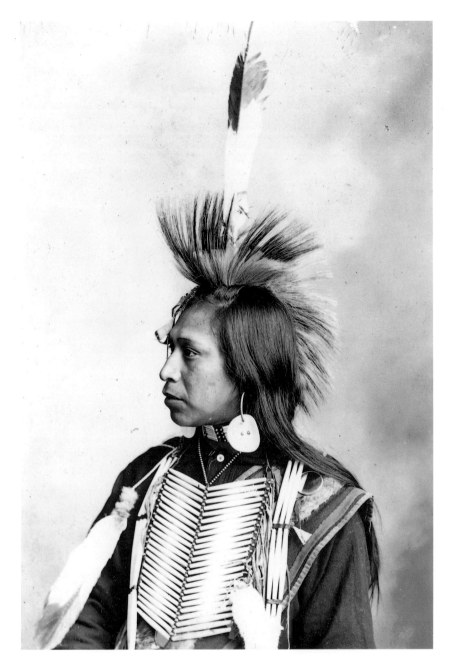

BENJAMIN A. GIFFORD, *A KLICKITAT BRAVE,* © 1899.

The Klickitat, a small tribe in southwestern Washington, moved in 1855 from their traditional territory to the Yakima Reservation, where their culture quickly disintegrated. This brave's hair brings to mind the influence of Native American attire upon American and European youth culture in the 1960s, 1970s, and 1980s, which coincided with a boom in Curtis photographs. Because they seem close to the earth and the natural environment, Native Americans have long inspired those disaffected with modern industrial society.

115

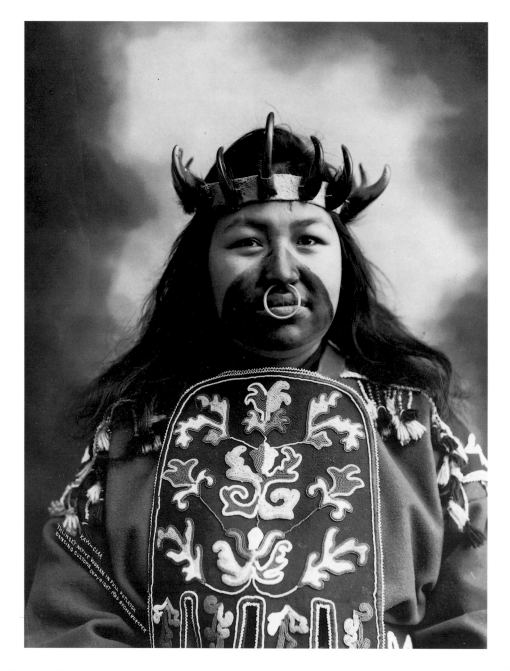

CASE AND DRAPER, *KAA-CLAA. TLINGET NATIVE WOMAN IN FULL POTLATCH DANCING COSTUME,* © 1906.

The potlatch ceremony, common to most Northwest Coast tribes, was a species of passive-aggressive behavior. One family or clan gave a great number of its possessions to another to prove its power and dominance over the other. Likened to gambling, it has periodically been banned by authorities. The importance of the ceremony is denoted by the woman's queenlike costume.

116

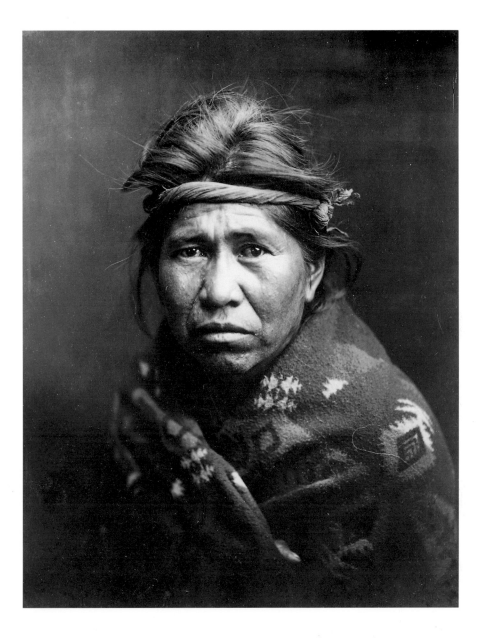

WILLIAM J. CARPENTER, *A STRONG CHARACTER
(NAVAJO SERIES)*, © 1914.

*Carpenter, who operated out of Spokane, Washington, and
Rossland, British Columbia, traveled to Navajo country for this
series, which includes several highly unconvincing action images
of ancient, frail braves on the warpath. This portrait, however,
is very much in the style of Edward Curtis, who was
beginning to have his imitators.*

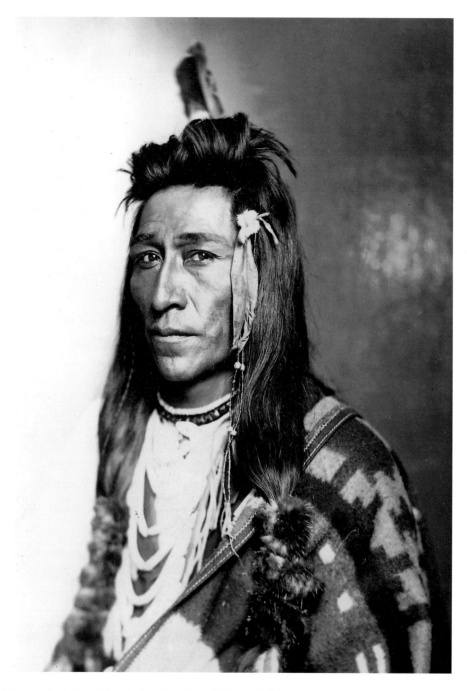

ROSE AND HOPKINS, *WEASAW—SHOSHONI, NO. 1*, © 1899.

Nothing is known about this portrait but the copyright date and the photographers' business location, Denver. They might have photographed Weasaw at the Indian Congress of the 1898 Trans-Mississippi and International Exposition in Omaha. His skeptical expression is priceless—a Mona Lisa-like interrogation of anyone who returns his gaze.

118

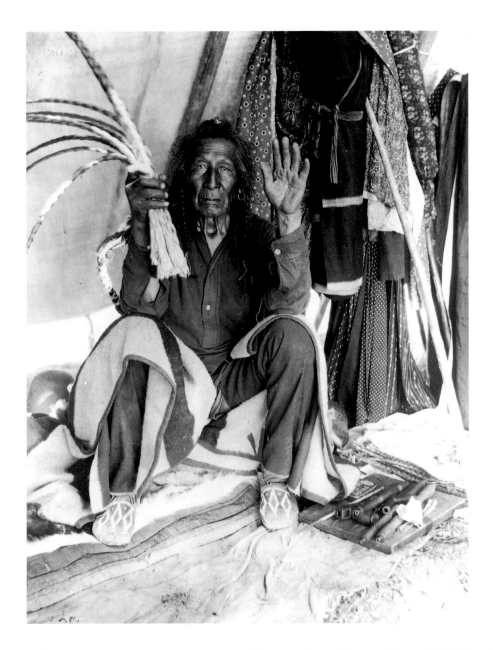

Photographer unknown, Detroit Publishing Company,
*NOSEY, MEDICINE MAN OF THE ASSINIBOINS,
FORT BELKNAP RESERVATION, MONTANA,* © 1906.

*Once numbering over twenty thousand, the Assiniboin were one
of the most powerful tribes of the upper Missouri. They were the
middlemen between the white traders from the United States and
Canada and the western tribes, and in Karl Bodmer's painting on
page 14, they are attacking the Blackfeet. By 1885, decimated by
disease, they had moved onto the Fort Belknap Reservation with
their enemies, the Blackfeet and the Atsina.*

119

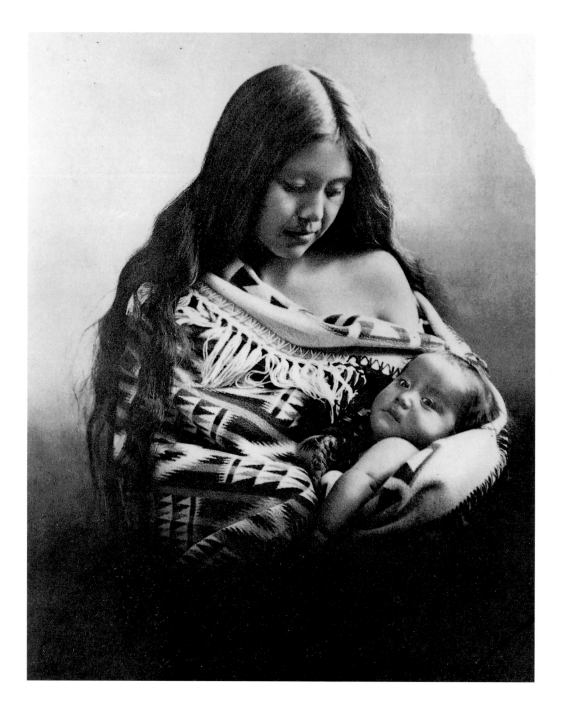

BENJAMIN A. GIFFORD, *OREGON'S INDIAN MADONNA,* © 1905.

*The Madonna theme not only evokes Christian sentimentality, but
also signals to the viewer that this is an art photograph. American
art at the turn of the century was often characterized by a return
to medieval and Renaissance motifs.*

120

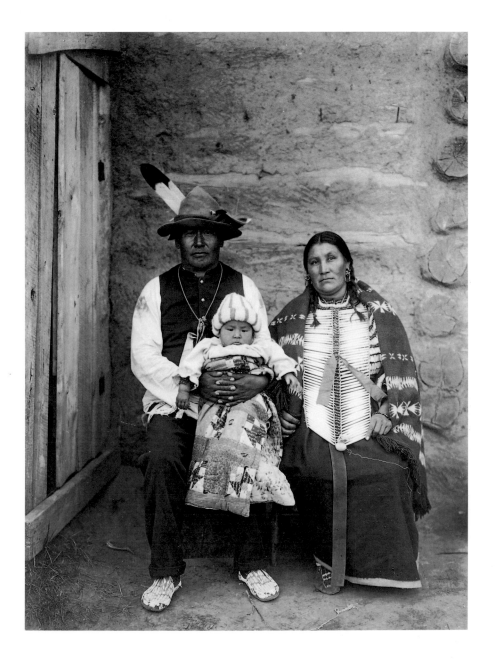

EDWARD S. CURTIS, *YELLOW BONE WOMAN*, © 1908.

The Arikara were once the fiercest warriors on the lower Missouri. In 1819, a large military force was sent to chastise them. It failed. Eventually the Arikara became scouts for the U.S. Army. The famous guide Bloody Knife, who died horribly with Custer at the Little Big Horn, was an Arikara. In later years the tribe was put on the Fort Berthold Reservation, where they merged with the Mandan and Hidatsa and lost their tribal identity. Curtis' family portrait indicates that loss.

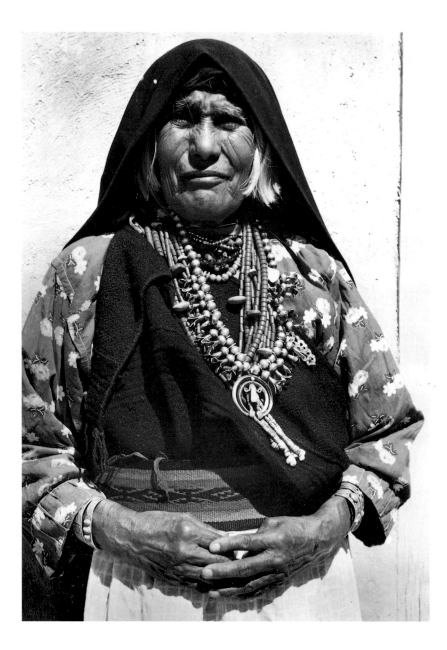

LAURA GILPIN, *OLD WOMAN, ACOMA PUEBLO,* © 1939.

Like her portrait of an Acoma man on page 64, Gilpin's depiction
of this Hopi matron is respectful and matter-of-fact. Looking down
slightly toward the camera lens, Gilpin's richly costumed subject
seems quite practiced at posing for white photographers—much
as Kenya's Masai warriors are today.

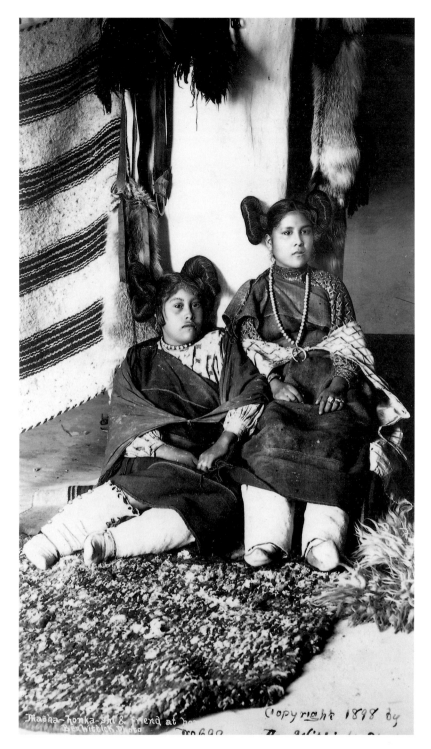

GEORGE BEN WITTICK, *MOQUI INDIAN GIRLS OF ORAIBI,*
MASHA-HONKA-SHI & FRIEND AT HOME, MOQUI, ARIZONA, © 1898.

Wittick photographed these Hopi virgins inside their apartment at
Oraibi, which he appears to have made into a studio. Views like
these sold extremely well as postcards.

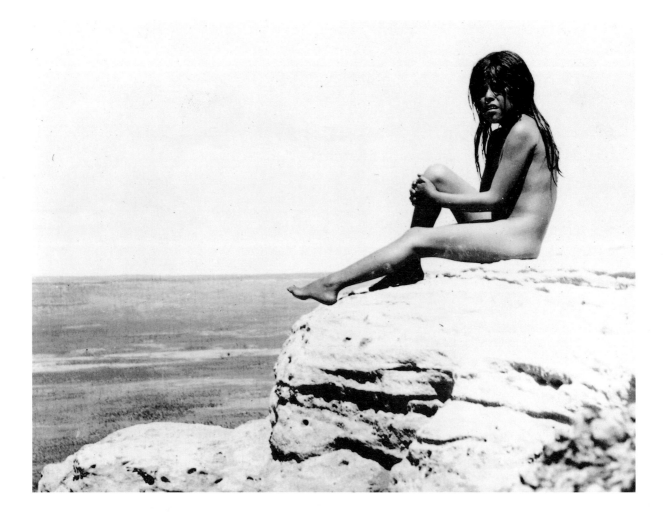

FREDERICK MONSEN, *A STUDY IN BRONZE,* © 1907.

This may be Monsen's artistic masterpiece, as sky and space and nature's child speak to the eternal. Soon New York's Photo-secession, if not the Armory Show of 1913 and the onset of Modernism, would dub this piece of classical Greek imagery hopelessly sentimental and outdated.

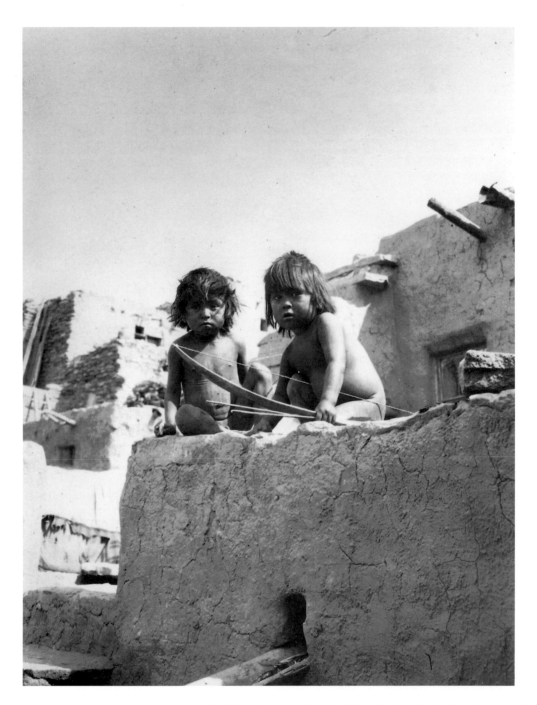

FREDERICK MONSEN, *THE SENTINELS, HOPILAND,* © 1908.

Monsen, who lived partly in Pasadena and partly at the Explorer's
Club in New York when he wasn't lecturing around the country,
had the best of two artistic worlds. An artist himself, he understood
the Renaissance classicism dominating the New York art scene,
especially in sculpture, and as the fascination with the primitive
became fashionable, he grasped its value—hence these native
cherubs and the Renaissance fawn on the opposite page.

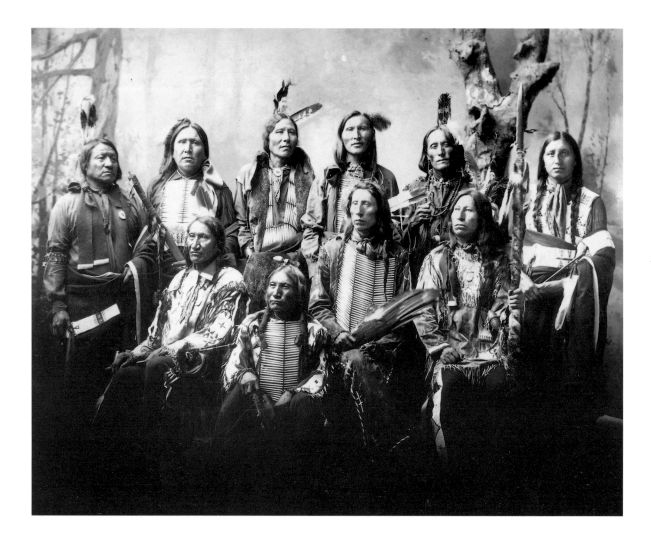

HERMAN HEYN, *CHIEF JACK RED CLOUD AND CHIEFS,* © 1899.

Heyn probably photographed these Sioux war chiefs at the Indian Congress of the 1898 Trans-Mississippi and International Exposition in Omaha. The warriors, from left to right, are (standing) Painted Horse, Bear Foot, an unidentified man, Black Horn, Bird Head, and George Little Wound and (seated) Rocky Bear, Broken Arm, Jack Red Cloud, and Lone Bear. According to anthropologist James Mooney, the Indian Congress, intended as a dignified gathering of the tribes, rapidly "degenerated into a wild west show."

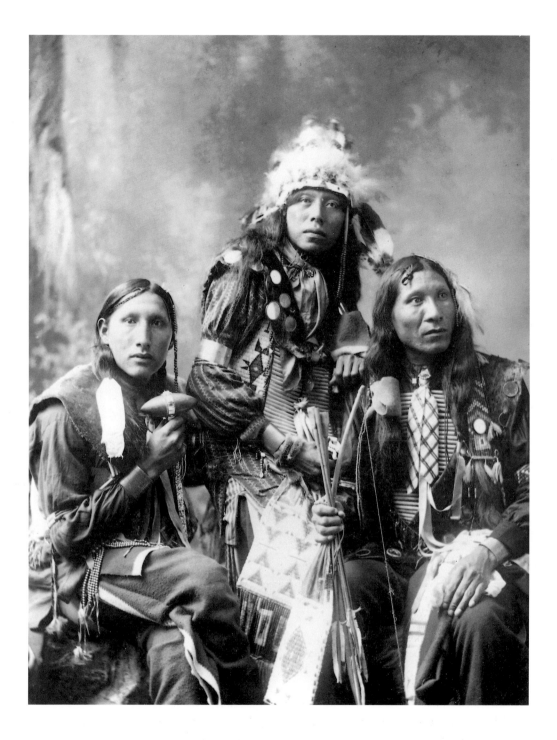

HERMAN HEYN, *POOR ELK, SHOUT FOR, EAGLE SHIRT,* © 1899.

*Heyn also posed this group portrait during the Indian Congress.
Pictures of warrior chiefs in all their finery appealed to tourists'
image of the West. Of course, no Native American went into battle in
these clothes. This is indeed a Native American "society" portrait.*

127

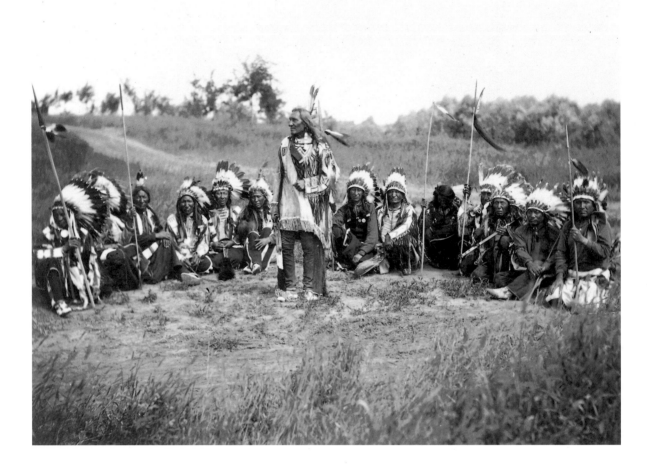

HERMAN HEYN, *CHIEF LITTLE WOUND IN COUNCIL,* © 1899.

Heyn's staged council meeting was also made at the Indian Congress at Omaha in 1898. Portrayals of Indians speaking in council are as old as a Jacques Le Moyne painting of conferring Florida natives engraved and published by Theodor de Bry in 1591 and as recent as the Sioux council scenes in the movie Dances with Wolves.

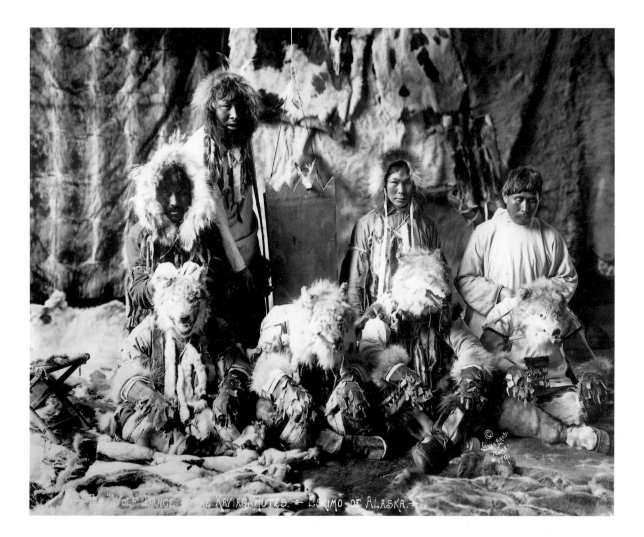

LOMEN BROTHERS, *THE WOLF DANCE OF THE KAVIAGAMUTE
ESKIMOS OF ALASKA*, date unknown.

*The Lomen Brothers were frontier photographers in Nome, Alaska.
The Kaviagamute Wolf Dance was aimed at warding off wolves.*

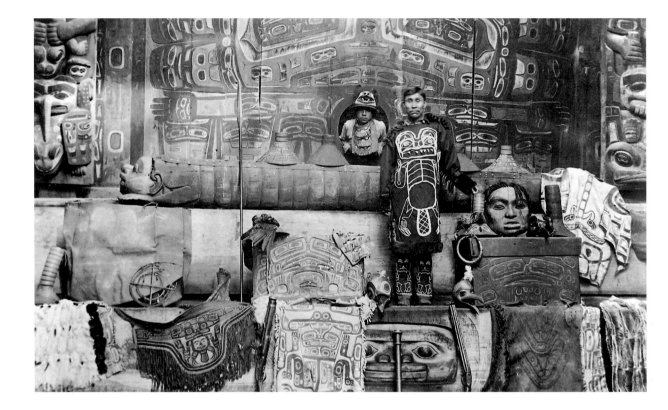

LLOYD WINTER AND PERCY POND, *INTERIOR OF CHIEF KLART-REECH'S HOUSE, CHILKAT, ALASKA,* © 1896.

Winter and Pond combined a photography studio and Indian curio shop in Juneau, Alaska. They accidentally stumbled into a secret potlatch and were made members of the Chilkat tribe, which enabled them to take this stunning interior view of the Whale House or Chief Klart-Reech's house, the center of Chilkat ceremonies in Klukwan. Here the family's affluence is on display: a spectacular house screen called a Rain Screen, elaborately carved house posts, fancy boxes, helmets, spruce-root hats, a dance apron, two guns, and an enormous carved human head. The picture was taken with flash powder and, when cropped, sold as a postcard—violating the sanctity of the Whale House.

130

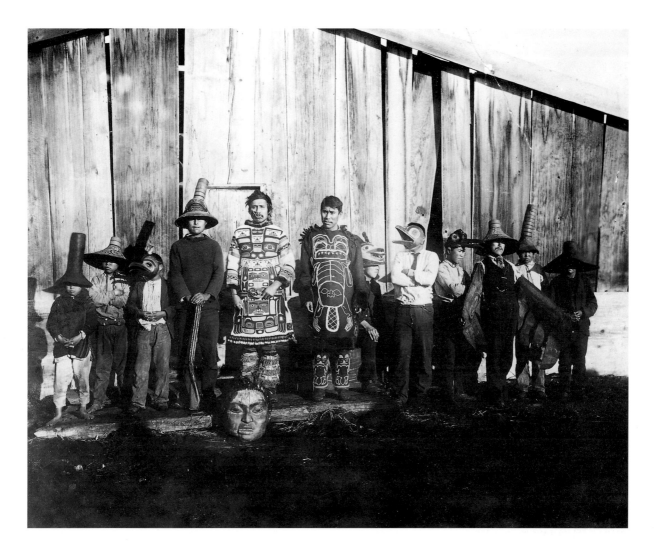

LLOYD WINTER AND PERCY POND, *EXTERIOR OF
CHIEF KLART-REECH'S HOUSE, CHILKAT, ALASKA,* © 1895.

*Chief Yeilgooxu and the Gaanaxteidl clan stand outside the Whale
House, which is tent-shaped and perhaps sixty feet across.
Dressed in traditional Chilkat dancing aprons, stove-pipe hats
made from spruce tree roots, and painted leather wings, these
natives also wear vests, watch chains, neckties, trousers, and
other pieces of European clothing, attesting to the acculturation
process even in the sacred precincts of the ceremonial Whale House.*

131

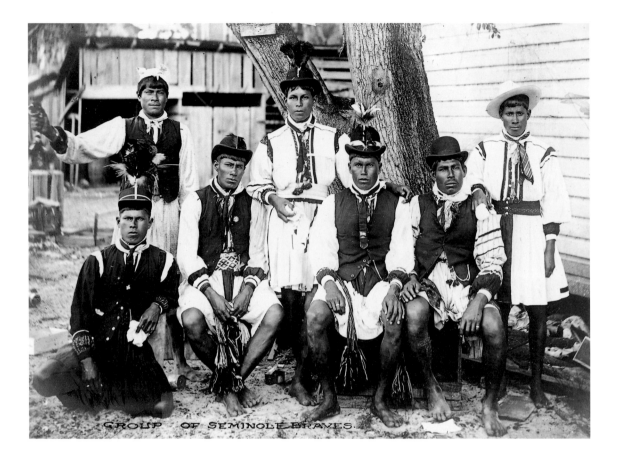

GROUP OF SEMINOLE BRAVES.

Photographer unknown, *GROUP OF SEMINOLE BRAVES*, date unknown.

The Wittemann collection, in which this photograph was found, includes many images taken at new Florida resorts around 1900 and published in souvenir photogravure booklets by the Albertype Company of Brooklyn, New York. The photographer may be John N. Chamberlain of Massachusetts, who included similar group photos of Seminoles in his 1904 Albertype souvenir booklets of the Miami area. Tourists must have been intrigued with the distinctive costumes of the Seminoles, an indigenous Florida tribe which intermarried with African American slaves.

132

EPILOGUE

This has not been a scientific survey, but a glimpse of what can be seen, thanks to the camera, of long-ago Native American men, women, and children. We have costumes and other artifacts in museums which are prime clues to the Native American past. We also have a plethora of paintings by artists such as George Catlin, and speeches, printed and recorded, to tell us about Native Americans, their ways of life and even, on occasion, their attitudes, despite language barriers and nuances of speech.

Photographs also remain an important means of communication with a now lost Native American past. They catch expressions and emotions perhaps better than any other form. They often deglamorize the Native American experience and have the appearance of greatest reality. But we have to remember that they are a very special kind of reality. In Jean Baudrillard's words, they are "simulacra." They are real only insofar as they are objects made by the photographer, whose motives for photographing Native Americans as he did were complex and diverse. To nineteenth-century photographers, Native Americans were Indians, a European invention. Few of the photographers transcend the perceptual limitations of that term, though this does not preclude them from using their photographs as tools of reform movements or demonstrations of Anglo-Saxon superiority.

Ironically (and irony is a primary theme of this book), because they are posed ceremonial photos, we should compare these Indian pictures with white society and wedding pictures. Edward Curtis had the opportunity to try his hand at both and translate the conventions of the latter to the former, but students of photography or culture have yet to compare the two sides of his photographic enterprise. I do not think it is going too far to assert that all surviving Indian photographs, including not only the Library of Congress holdings, but those of the Museum of Anthropology and the National Archives, are as ceremonial as an album of wedding pictures. In fact, the

ceremonial should perhaps be deemed a discreet genre of photography, like the documentary. Ceremonial pictures far outnumbered all other types of photos taken by professionals in the nineteenth- and early twentieth- centuries. Few had the time or the inclination or the technology to waste time on the kind of candid shots which the late Garry Winogrand believed come closer to reality—but which do not sell. In nineteenth and early twentieth century America, photographers were more formal, less candid than Eugene Atget and the other great French street photographers, who could make an unforgettable picture of a very pregnant street dog— something even Lewis Hine, with his pseudo-candid Tenderloin shots, could not match.

Neither our series of photos or any other photo archive can tell the whole story of the native in America. One can read Samuel Kercheval's *A History of the Valley of Virginia* or Samuel Wilbarger's *Indian Depredations in Texas* and learn of the unbelievably bloody, savage struggle between red people and white that took place on this continent. Photos capture little of this, just as the worst parts of the Civil War were not captured by Mathew Brady's team of photographers. Today, the photographic record leaves us only sympathy, if not grief, for the "vanishing American." Yet it is easy to forget that both red people and white vanished. Some glibly call it conquest. It could just as well be a chapter of the unending human struggle to survive. As the globe gets smaller, that struggle becomes more intense. As cultures and races grow closer, understanding grows. But in equal measure the concept of "the other" provokes ever-greater anxieties, as Edward Said makes clear in *Orientalism*, which pleads the case for his Arab brethren.

One of the good, rather than sad, things about this book is that it opens up possibilities for understanding the "others" of the past. It leaves room for humor and personal impressions. It certainly leaves room for, beckons for, further study of Native Americans and those who photographed them. If its relative informality is successful, it offers one more opportunity—an extended conversation with the photographers of Native Americans of the past, who speak to us about them as they knew them, even as we speak to and acknowledge their subjects and their work.

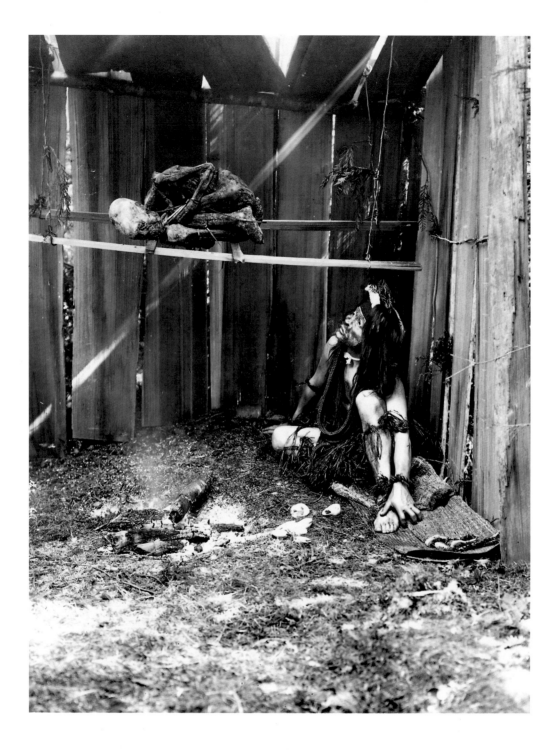

EDWARD S. CURTIS, *THE DRYING MUMMY,* © 1910.

Curtis's half-Tlinget assistant, George Hunt, poses as a Kwakiutl watching the preparation of a mummy for a spiritual observance. Curtis often posed Hunt in portrayals of sensitive or sacred rituals. He was therefore able to capture ceremonial Kwakiutl images that would not have been available to him otherwise.

136

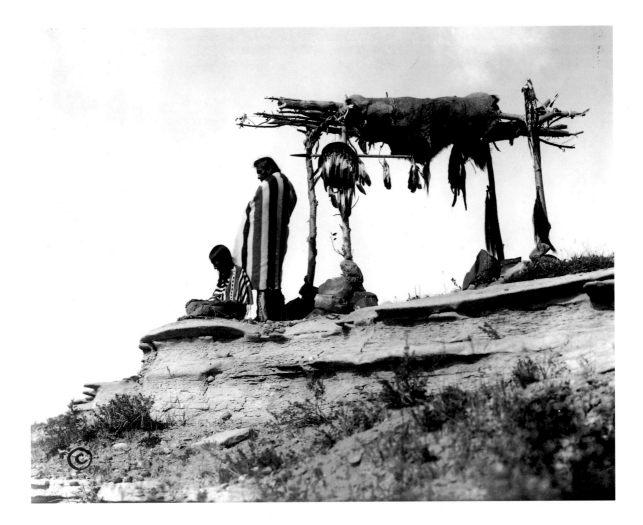

ROLAND REED, *TRIBUTE TO THE DEAD*, © 1912.

Reed has audaciously photographed a Blackfoot burial platform. In accordance with Blackfoot custom, a young warrior's remains had been placed there to protect them from predators and, by implication, to bring them nearer the sky wherein the gods dwelled. Note the warrior's possessions attached to the platform.

Reed, who was often sentimental in his views, has nicely understated the sentiment in this posed picture, but when he clicked the camera shutter, the father became enraged and destroyed the platform, carrying his dead son away in his arms.

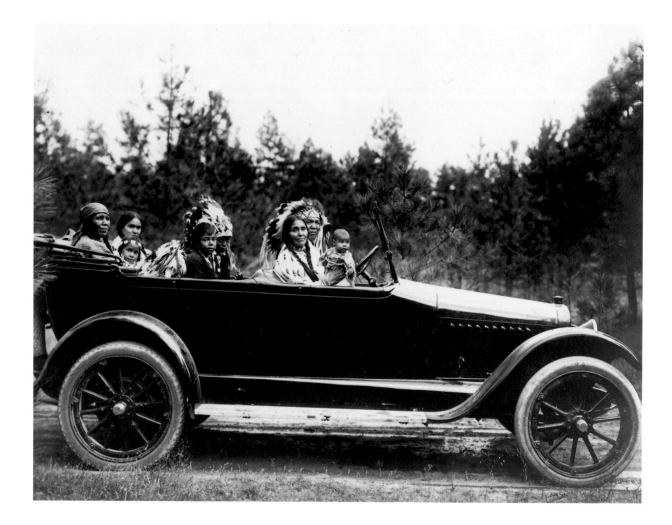

FRANK PALMER, *GROUP OF NEZ PERCE*, © 1916.

Palmer, a Spokane, Washington, resort photographer, made his most widely distributed picture by posing Nez Perce (some sources say Yakima) Indians poised for a spin in a three-seated car just outside Spokane. In contrast to the two previous images, Palmer's appears to be a happy "resurrection." It also anticipates the almost complete effacement of a native American culture beguiled by the white man's technology; another kind of death. Frank Palmer sold 15,000 postcards in 1910 alone.

ACKNOWLEDGMENTS

This has been a more difficult book to write than it may seem. My primary debt is, of course, to the Library of Congress for making the photographs available. Several individuals, however, made this project possible, especially my administrative assistant, Mary Harmon, who typed innumerable drafts of what, logistically speaking, became a very complex manuscript. She also offered suggestions and encouragement. William Pugsley, my research assistant, was most enthusiastic in his pursuit of material on obscure photographers. Tim Davis called my attention to the boffo Baudrillard, whose theoretical insights inform this book. And finally there is my editor, Owen Andrews, who has been dogged in his insatiable pursuit of excellence. In conclusion, I am grateful to my daughter Anne, who suggested that I accompany my manuscript with a note saying, "I hope this helps."

William H. Goetzmann

The editors would like to thank Dana Pratt and Peggy Wagner of the Publishing Office of the Library of Congress for their advice and assistance, and Jerry Kearns of the Prints and Photographs Division for generously sharing his expertise about the Library's photographs of Native Americans.

SOURCES

Anderson, John Alvin. Frontier Photographer, *Nebraska History*, vol. 51, no. 4 (1970), pp. 469-80.

Andrews, Ralph Warren. *Curtis' Western Indians*. Seattle: Superior Publishing Company, 1962.

Andrews, Ralph Warren. *The Art Work of Seattle and Alaska*. Seattle: 1907.

Andrews, Ralph Warren. *Photographers of the Frontier West*. New York: Bonanza Books, 1965.

Baudrillard, Jean. *America*. London, New York: Verso, 1988.

Baudrillard, Jean. *Simulations*. Translated by Paul Foss, Paul Patton, and Phillip Beitchman. New York: Semiotext(e) Inc., 522 Philosophy Hall, Columbia University, 1983.

The Holy Bible, Authorized King James Version, World Bible Publishers, Inc.

Bigart, Robert and Woodcock, Clarence. "The Rinehart Photographs: A Portfolio," *Montana, The Magazine of Western History*. Vol. 29, no. 4, Oct. 1979, pp. 14-25. Contains details of the Grand Indian Congress at the Trans-Mississippi and International Exposition in Omaha, Nebraska, 1898.

Britain, J.W. Kalispell, Montana, Indian Portraits. Washington, D.C.: Library of Congress, entered 1902.

Bulfinch, Thomas. *Bulfinch's Mythology Illustrated*. repr. ed. New York: Averal Books, 1990.

Campbell, Joseph. *The Hero With a Thousand Faces*. Princeton: Princeton University Press, 1949.

Catlin, George. *Letters and Notes of the Manners, Customs and Condition of the North American Indians....* Philadelphia and London, 1841. 2 vols.

Coe, Ralph T. *Lost and Found Traditions: Native American Art, 1965-1985*. Seattle: University of Washington Press, 1986.

Coke, Van Deren. *Photography in New Mexico from the Daguerreotype to the Present*. Albuquerque, New Mexico: University of New Mexico Press, 1979.

Crofutt, George A. *Crofutt's New Overland Tourist and Pacific Coast Guide....* Omaha, Nebraska, and Denver, Colorado: 1869.

Current, Karen and William. *Photography and the Old West*. New York, Harry N. Abrams, Inc. in association with the Amon Carter Museum, 1978.

Curtis, Edward S. Miscellaneous correspondence with Frederick Webb Hodge. Southwest Museum.

Curtis, Edward S. Miscellaneous letters to Harriet Leitch. Seattle Public Library.

Curtis, Edward S. Miscellaneous manuscripts, Northwest Collection, University of Washington Library.

Curtis, Edward S. *The North American Indian*. 20 vols. and 20 portfolios. New York: Privately Printed, 1907-1930.

Daniels, David. "Photography's Wet-plate Interlude in Arizona Territory, 1864-1880." *The Journal of Arizona History*, vol. 9, no. 4, pp. 171-94.

Darnell, Regina. "The Development of American Anthropology, 1879-1920: From the Bureau of American Ethnology to Franz Boas." Ph.D. dissertation, University of Pennsylvania; Ann Arbor University Microfilms, 1969.

Dippie, Brian. *Catlin and His Contemporaries: the Politics of Patronage*. Lincoln and London: University of Nebraska Press, 1990.

Fiske, Turbese Lummis and Lummis, Keith. *Charles E. Lummis, The Man and His West*. Norman, Oklahoma: University of Oklahoma Press, 1975.

Fleming, Paula Richardson and Luskey, Judith. *The North American Indians in Early Photographs*. New York: Dorset Press, 1986.

Gerbi, Antonello. *Nature in the New World From Christopher Columbus to Gonzalo Fernandez de Oviedo*. Translated by Jeremy Moyle. Pittsburg: University of Pittsburg Press, 1985.

Gidley, Mick. "Edward S. Curtis Speaks...." *History of Photography, an International Quarterly*, vol. 2, no. 4, Oct. 1978, pp. 347-54.

Gidley, Mick. *The Vanishing Race*. New York: Taplinger Publishing Co., 1977.

Goetzmann, William H. and Goetzmann, William N. *The West of the Imagination*. New York: W.W. Norton, 1986.

Goetzmann, William H. *Army Exploration in the American West*. New Haven: 1959.

Goetzmann, William H. *Exploration and Empire*. New York: Alfred A. Knopf Inc., 1966. Reprint, W.W. Norton.

Goetzmann, William H. *Looking at the Land of Promise: Pioneer Images of the Pacific Northwest*. Pullman, Washington: Washington State University Press, 1989.

Goetzmann, William H.; Orr, William; Hunt, David; and Gallagher, Marsha. *Karl Bodmer's America*. Lincoln, Nebraska: University of Nebraska Press, 1984.

Goetzmann, William H. and Sloan, Kay. *Looking Far North: The Harriman Expedition to Alaska, 1899*. New York: Viking Press, 1982.

Grand Indian Congress. *Chicago Times-Herald*, Oct. 29, 1899.

Grand Indian Congress. *Omaha Daily Bee*, July 20, 1898.

Grant, Bob. "Lee Moorhouse, Early Photographer Leaves 10,000 Plates." *Pioneer Trails*, vol. 3, no. 3, pp. 3-5. Umatilla County, Oregon, April 1979.

Grabill, John C.H. "Grabill's Photographs of the Last Conflict Between the Sioux and the United States Military, 1890-91." *South Dakota History*, vol. 14, no. 3 (1984), pp. 222-37.

Grabill, John C.H.; Boesen, Victor; and Curtis, Florence. *Edward Sheriff Curtis, Visions of a Vanishing Race*. New York: Thomas Y. Crowell Co., 1976.

Hales, Peter Bacon. *William Henry Jackson and the Transformation of the American Landscape*. Philadelphia: Temple University Press, 1988.

Hamilton, Edith. *Mythology: Timeless Tales of Gods and Heroes*. New York: Mentor Books, 1971; originally published 1940.

Hamilton, Henry W. and Tyree, Jean. Photographs by John A. Anderson. *The Sioux of the Rosebud: A History in Pictures*. Norman, Oklahoma: The University of Oklahoma Press, 1971.

Hinsely, Curtis M., Jr. *Savages and Scientists: The Smithsonian Institution and the Development of American Anthropology*. Washington, D.C.: The Smithsonian Institution Press, 1981.

Holm, Bill and Quimby, George Irving. *Edward S. Curtis in the Land of the War Canoes: a Pioneer Cinematographer in the Pacific Northwest*. Seattle and London: University of Washington Press, 1980.

Holm, Bill. Review of Christopher Lyman, "The Vanishing Race and Other Illusions: Photography of Indians by Edward S. Curtis." *American Indian Art*, vol. 8, no. 3, Summer 1983, pp. 68-73.

Holmes, William H. "Random Records of a Lifetime in Science and Art." Miscellaneous scrapbooks, Smithsonian Institution.

Honour, Hugh, *The New Golden Land: European Images of America From the Discoveries to the Present Time*. New York: Pantheon Books, 1975.

Honour, Hugh. *The European Vision of America*. Cleveland: Cleveland Museum of Art, 1975.

Hyde, Ann Farrar. *An American Vision: Far Western Landscape and National Culture, 1820-1920*. New York: New York University Press, 1990.

Johnson, Patricia Cardon. "The Indian Photographs of Roland Reed." *American West*. Vol. 15, no. 3, March/April 1978, pp. 44-57.

Josephy, Alvin, Jr. *The Indian Heritage of America*. New York: Alfred A. Knopf Inc., 1968.

Josephy, Alvin. "The Splendid Indians of E.S. Curtis." *American Heritage*, vol. 25, no. 2., Feb. 1974. pp. 40-59.

Kasebier, Gertrude. See *Macmillan Biographical Encyclopedia of Photographic Artists and Innovators*, p. 320. Toronto, New York: 1983.

Lyman, Christopher M. *The Vanishing Race and Other Illusions: Photography of Indians by Edward S. Curtis*. Washington, D.C.: Smithsonian Institution and Pantheon Books, 1982.

Mahood, Ruth, ed. *Photographer of the Southwest, Adam Clark Vroman 1856-1916*. Los Angeles: Ward Ritchie Press, 1961.

Mangan, Terry and Harber, Opal. "Directory of Early Photographs." *Colorado on Glass*. Denver: Sundance Ltd., n.d.

Mattison, David B. "William Jefferson Carpenter, *Camera Workers: The British Columbia Photographers Directory 1858-1900*. Victoria, B.C.: Workers Press, 1985.

McLuhan, T.C. *Dream Tracks, the Railroad and the American Indian, 1890-1930*. New York: Harry N. Abrams, Inc., 1985.

McLuhan, T.C. *Portraits from North American Indian Life*. New York: Promontory Press, 1972.

McNeal, _____, "Benjamin A. Gifford." *History of Wasco County*, p. 62. Dalles, Oregon.

McRae, William E. "Images of Native Americans in Still Photography," *History of Photography*. Oct.-Dec. 1989, pp. 321-342.

Meany, Edmond S. "Hunting Indians With a Camera." *World's Work*, March 1912. no. 15, 10004-11.

Merriam, C. Hart. Correspondence ms. in the Brancroft Library, Stanford University.

Mitchell, Lee Clark. *Witnesses to a Vanishing America: The Nineteenth Century Response*. Princeton: Princeton University Press, 1982.

Mitchell, Lynn Marie. "George E. Trager: Frontier Photographer at Wounded Knee." *History of Photography*. Oct./Dec. 1989, pp. 303-309.

Monroe, Robert. "Frank LaRoche: Washington's 'Other' Indian Photographer." *Northwest Photography*, 1981.

Muhr, F.A. "A Gum-Bichromate Process for Obtaining Colored Prints from a Single Negative." *Camera Craft*. vol. 13, August 1906, pp. 276-81.

Muhr, F.A. "E.S. Curtis and His Work." *Photo-Era*. vol. 10, July 1907, pp. 9-13.

National Geographic Society. *The World of the American Indian*. Washington, D.C.: The National Geographic Society, 1974. See especially accompanying map.

Noelke, Virginia. "The Origin and Early History of the B.A.E., 1879-1910." Ph.D. dissertation, The University of Texas at Austin; Ann Arbor: University Microfilms.

Nolan, Edward W. "Summer at the Lakes: An Album of Frank Palmer's Photographs." *Idaho Yesterdays*. Summer 1990, pp. 16-20.

Novak, Michael. *That Noble Dream*. Cambridge, England: 1988.

Nowell, Frank. See *Macmillan Biographical Encyclopedia of Photographic Artists and Innovators*, p. 458. Toronto, New York: 1983.

Oregon Historical Society Files. Benjamin Arthur Gifford: "Gifford's Widow Gives Pictures to Museum;" Winquatt Museum, "Sunset on the Columbia," file #570, Gi 12416, "Photographers of the Columbia River Gorge" (Benjamin A. Gifford, Fred A. Kizer, Carleton E. Watkins, Edward S. Curtis, Isaac Grundy Davidson, and Lily E. White); "Carl Maritz Presents a Public Showing of Vintage Oregon Photography by Benjamin A. Gifford," Nov. 26, 1977; Benjamin A. Gifford, obit., 1930, *Oregon Daily Journal*, Portland. Robert W. Grant, "Leander Moorhouse;" *Sunday Oregonian*. "Northwest Magazine," 11/13/77; Dorys Craw, "Pioneer Hobby May Go to Local Library" (Major Leander Moorhouse; photographer), *Pendleton East Oregonian*, Feb. 27, 1958.

Ostroff, Eugene. *Western Views and Eastern Visions*. Washington, D.C.: Smithsonian Institution Press, 1981.

Packard, Gar and Maggy. *Southwest in 1880 with Ben Wittick Pioneer Photographer of Indian and Frontier Life*. Santa Fe: Packard Productions, 1970.

Pound, Ezra. *The Cantos*. New York: New Directions Press, 1970.

Reed, Roland. "Photographs of the Piegan by Roland Reed." Ed. and intro. Jay Ruby, *Studies in Visual Communication*, vol. 7, no. 1, Winter 1981, pp. 48-51.

Reed, Roland. See *Macmillan Biographical Encyclopedia of Photographic Artists and Innovators*, p. 502. Toronto, New York: 1983.

Rich, W.C., Jr. "American Indian Life Preserved in Portraits" (Roland Reed). *Minneapolis Journal*. Sunday, Jan. 20, 1935, pp. 4 ff.

Rinehart, Frank A. *Frank A. Rinehart's Prints of American Indians*. Omaha, Nebraska: Frank A. Rinehart, 1900.

Ruby, Jay, ed. and intro., "Photographs of the Piegan by Roland Reed" (photo essay). *Studies in Visual Communication*. vol. 7, no. 1, Winter 1981, pp. 48-62, Philadelphia: Annenberg School Press, 1981.

Rudisill, Richard. *Photographers of New Mexico Territory 1854-1912*. Albuquerque, New Mexico: Museum of New Mexico, 1973.

Sandweiss, Martha A. *Laura Gilpin, an Enduring Grace*. Fort Worth, Texas: Amon Carter Museum.

Scherer, Joanna C. and Burton, Jean. *Indians: The Great Photographs that Reveal North American Indian Life 1847-1927, from the Unique Collection of the Smithsonian Institution*. New York: Crown Publishers Inc., 1973.

Scherer, Joanna Cohan. "You Can't Believe Your Eyes: Inaccuracies in Photographs of North American Indians." *Studies in the Anthropology of Visual Communication*, vol. 2, no. 2, 1975, pp. 67-79.

Scherer, Joanna Cohan. Review of Christopher Lyman, "The Vanishing Race and Other Illusions: Photography of Indians by Edward S. Curtis." *Studies in Visual Communication*, vol. 11, No. 3, Summer 1985.

Sontag, Susan. *On Photography*. New York: Delta Books, 1973.

Sutton, Royal. *The Face of Courage: Indian Photographs of Frank A. Rinehart*. Fort Collins, Colorado: Old Army Press, 1972.

Swanston, W.R. "Map of the Indian Tribes of the United States." *United States National Atlas*. Reston, Virginia: United States Geological Survey.

Taft, Robert. *Photography and the American Scene*. New York: Dover Publications, 1964; first published by Macmillan Co. in 1938.

Trachtenberg, Alan. *Reading American Photographs*. New York: Hill and Wang, 1989.

Underhill, Ruth. *Red Man's Religion*. Chicago: University of Chicago Press, 1965.

Utley, Robert M. *The Indian Frontier of the American West, 1846-1890*. Albuquerque, New Mexico: University of New Mexico Press, 1984.

Utley, Robert M. *The Last Days of the Sioux Nation*. New Haven: Yale University Press, 1963.

Van Valkenberg, Richard. "Ben Wittick: Pioneer Photographer of the Southwest." *Arizona Highways*, vol. 18, no. 8, 1942, pp. 36-39.

Viola, Herman. *Diplomats in Buckskins: A History of Indian Delegations in Washington City*. Washington, D.C.: Smithsonian Institution Press, 1981.

Viola, Herman. *The Indian Legacy of Charles Bird King*. Washington, D.C.: Smithsonian Institution Press, 1976.

Waters, Frank. *The Book of the Hopi*. New York: Penguin Books, 1977-87; originally published 1963, Viking Press.

Watkin, Lee D. and London, Barbara. *The Photograph Collector's Guide*. Boston: New York Graphic Society, 1979.

Webb, William and Weinstein, Robert A. *Dwellers at the Source, Southwestern Indian Photographs of A.C. Vroman, 1895-1904*. Albuquerque, New Mexico: University of New Mexico Press, 1973.

Wittick, George Benjamin. See *Macmillan Biographical Encyclopedia of Photographic Artists and Innovators*, p. 673. Toronto, New York: 1983.

Wyatt, Victoria. *Images from the Inside Passage: An Alaskan Portrait by Winter and Pond*. Seattle and London, Juneau: University of Washington Press, 1989.

INDEX

For those who wish to contact the Library of Congress about specific photographs in this book, the Library's negative numbers, listed here by page, will expedite inquiries.

(4-5) LC-USZ62-101342; (7) *Brevis Narratio Eorum Qvai in Florida,* G159 .B7 pt.2 copy 5, Rare Book and Special Collections Division; (13) *North American Indian Portfolio,* Rare Book and Special Collections Division; (14) black-and-white engraving, *Travels into the Interior of North America,* E165 .W654 vol.1, Rare Book and Special Collections Division; (16) *History of the Indian Tribes,* E77 M13, Rare Book and Special Collections Division; (21) LC-USZ62-52200 (27) LC-USZ62-101196; (28) LC-D6-49; (31) LC-USZ62-101334; (32) LC-USZ62-101168; (33) LC-USZ62-101155; (34) LC-USZ62-72156; (35) LC-USZ62-101199; (36) LC-USZ62-101156; (37) LC-USZ62-101161; (38) LC-USZ62-101185; (41) LC-USZ62-101262; (42) LC-USZ62-19725 or LC-USZ62-15575; (43) LC-USZ62-71321; (44) LC-USZ62-99803; (45) LC-USZ62-49149 or LC-USZ62-99367; (46) LC-USZ62-101288; (47) LC-USZ62-46967; (48) LC-USZ62-101181; (49) LC-USZ62-101179; (50) LC-USZ62-46970; (51) LC-USZ62-51436; (52) LC-USZ62-101173; (53) LC-USZ62-101255; (54) LC-USZ62-101339; (55) LC-USZ62-84942; (56) LC-USZ62-101184; (57) LC-USZ62-101189; (58) LC-USZ62-101258; (59) LC-USZ62-101338; (60) LC-USZ62-101270; (61) LC-USZ62-101188; (62) LC-USZ62-8904; (63) LC-USZ62-78487; (64) LC-USZ62-102683; (67) LC-USZ62-101154; (68) LC-USZ62-101333; (69) LC-USZ62-101332; (70) LC-USZ62-101160; (71) LC-USZ62-101243; (72) LC-USZ62-93744; (73) LC-USZ62-94089; (74) LC-USZ62-49436; (77) LC-USZ62-48420; (78) LC-USZ62-101263; (79) LC-USZ62-46984; (80) LC-USZ62-101287; (81) LC-USZ62-46978; (82) LC-USZ62-4458; (83) LC-USZ62-20041; (84) LC-USZ62-90799; (87) LC-K2-90; (88) LC-USZ62-86438; (89) LC-USZ62-101174; (90) LC-USZ62-101195; (91) LC-USZ62-101337; (92) LC-USZ62-101175; (93) LC-USZ62-101193; (94) LC-USZ62-101165; (95) LC-USZ62-101194; (96) LC-USZ62-101251; (97) LC-USZ62-101336; (98) LC-USZ62-101162; (99) LC-USZ62-90214; (100) LC-USZ62-64971; (101) LC-USZ62-96189; (102) LC-USZ62-97091; (103) LC-USZ62-58914; (104) LC-USZ62-79541; (105) LC-USZ62-80026; (106) LC-USZ62-101178; (107) LC-USZ62-52196; (108) LC-USZ62-86441; (109) LC-USZ62-41455; (110) LC-USZ62-101253; (111) LC-USZ62-101284; (112) LC-USZ62-101197; (113) LC-USZ62-101198; (114) LC-USZ62-101328; (115) LC-USZ62-101330; (116) LC-USZ62-101170; (117) LC-USZ62-101324; (118) LC-USZ62-101280; (119) LC-USZ62-47850; (120) LC-USZ62-101276; (121) LC-USZ62-101183; (122) LC-USZ62-36220; (123) LC-USZ62-101153; (124) LC-USZ62-101158; (125) LC-USZ62-101159; (126) LC-USZ62-55847; (127) LC-USZ62-101267; (128) LC-USZ62-101269; (129) LC-USZ62-101282; (130) LC-USZ62-10926; (131) LC-USZ62-44194; (132) LC-USZ62-101151; (136) LC-USZ62-101256; (137) LC-USZ62-48427; (138) LC-USZ62-101166.